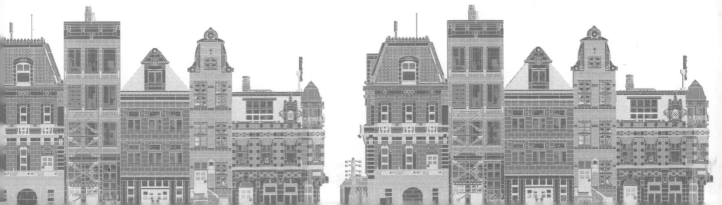

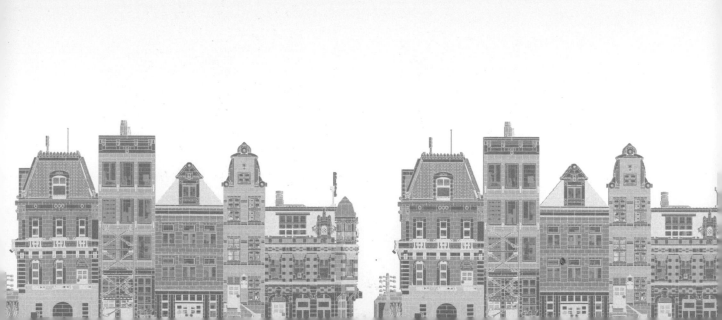

the LEGO® NEIGHBORHOODbook ②

BUILD YOUR OWN CITY! BRIAN LYLES AND JASON LYLES

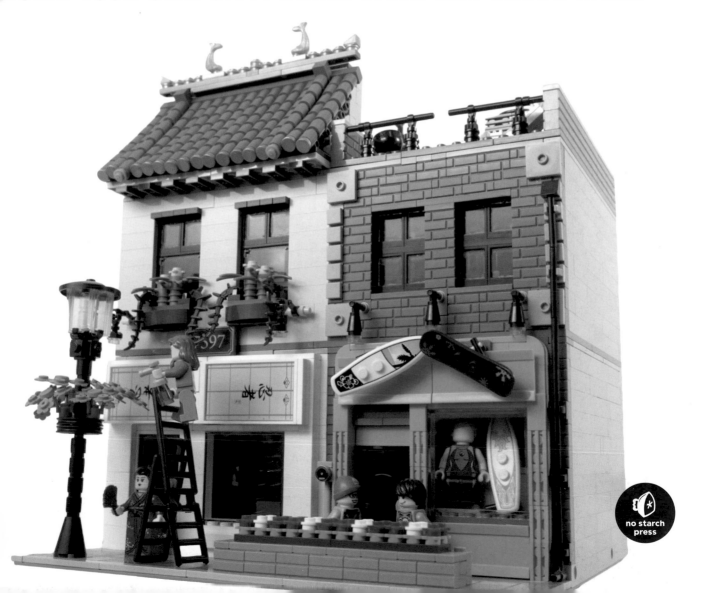

no starch press

The LEGO Neighborhood Book 2. Copyright © 2019 by Brian Lyles and Jason Lyles.

Printed in China

First printing

22 21 20 19 18 1 2 3 4 5 6 7 8 9

ISBN-10: 1-59327-930-2
ISBN-13: 978-1-59327-930-1

Publisher: William Pollock
Production Editor: Riley Hoffman
Cover Design: Mimi Heft
Cover Illustration: Mattia Zamboni
Developmental Editor: Tyler Ortman
Compositors: Riley Hoffman and Danielle Foster
Additional Image Preparation: Zane Foster
Proofreader: Emelie Burnette

For information on distribution, translations, or bulk sales, please contact No Starch Press, Inc. directly:

No Starch Press, Inc.
245 8th Street, San Francisco, CA 94103
phone: 1.415.863.9900; info@nostarch.com; www.nostarch.com

The Library of Congress has catalogued the first volume as follows:

Lyles, Brian.
 The LEGO neighborhood book : build your own town! / by Brian Lyles and Jason Lyles.
 pages cm
 Audience: Age 10.
 ISBN-10: 1-59327-571-4
 ISBN-13: 978-1-59327-571-6
 1. Neighborhoods--Models--Juvenile literature. 2. City planning--Juvenile literature. 3. LEGO toys--Juvenile literature. I. Lyles, Jason. II. Title.
 TD160.L95 2014
 688.7'25--dc23
 2014022194

Production Date: 6/19/2018
Plant & Location: Printed by Everbest Printing Co. Ltd., Guangdong, China
Job / Batch #: 82039 / EPC 814576

Contents

★ = pages with building instructions

INTRODUCTION v
 Base Size. vi
 Connecting the Buildings. vii

1 A RESIDENTIAL
 NEIGHBORHOOD 1
 American Colonial 2
 Colonial Interior 5
 ★ Piano. 6
 Boutique Hotel 7
 Art Deco Apartment Building. 10
 Art Deco Interior. 13
 ★ Display Cabinet. 14
 Italianate Row House 15
 ★ Barbecue Grill. 17
 Row House Interior 19
 Modern House 20
 Modern Interior. 25
 ★ Modern Couch 26
 Staircase Entrance. 27

2 A COMMERCIAL
 NEIGHBORHOOD 29
 Corner Store . 30
 Corner Store Interior 35
 ★ Soda Machine. 36
 Small Shops with Alley. 37
 Shop Interiors. 41
 ★ DVD Rental Kiosk and Sign 42
 Toy Store and Camera Shop 43
 Japanese Restaurant and Board Shop 46
 Board Shop Interior. 50
 Japanese Restaurant Interior. 51

 Ice Cream Shop 52
 ★ Toppings Bar. 56
 Small Vendor Stalls. 57
 ★ Window . 59
 Caribbean Restaurant 61
 Parisian Corner Café 64
 ★ Traffic Light 66

3 PUBLIC PLACES 69
 Embassy. 70
 Embassy Details. 74
 Brick City Park 75
 Park Details. 77
 War Monument 79
 War Monument Details 81
 The Top of the Tower. 82
 Art Museum . 83
 Art Museum Details. 85

4 GALLERY. 87
 Shops and Diners 88
 City Houses. 90
 Whimsical Buildings 91
 The Wild West 93
 Ancient Persia. 95
 Pirate City . 97

5 A MICRO CITY. 99
 Building in Microscale. 100
 A Smaller Standard 103
 Emergency Services 104
 Park and School. 106
 Neighborhood Buildings 108

Office Buildings .109
Factories .111
Commercial Buildings.113
Harbor. .116

★ CORNER CONDOMINIUMS 119
Bill of Materials. .120
 First Floor .123
 Second Floor .152
 Third Floor. .166
 Attic. .177
 Orange Roof .180
 Blue Roof. .182

Introduction

In our first book, *The LEGO Neighborhood Book*, we had a great time teaching you techniques for making your own buildings and giving you ideas and inspiration.

This time around, we'd like to give you a tour of some new neighborhoods and show how they connect to make a bigger city. Along the way, we'll look at new techniques, find some cool things to build, check out architectural styles in the city, and explore ways to bring your own city to life.

We can't wait to show you what we've created—but before we get started, here's a quick overview of the *Café Corner Standard* for modular buildings.

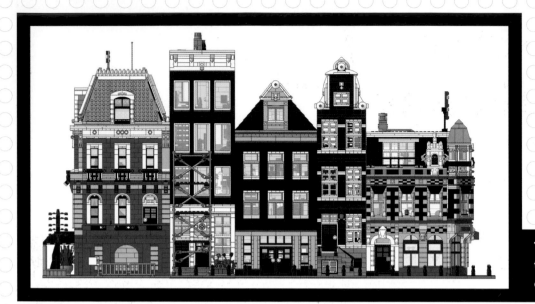

The buildings connect to form a block or row of buildings.

Base Size

All modular building sets to date use a 32×32-stud base, composed of either a single 32×32 plate or two 16×32 plates. So, to adhere to the standard, you need to build in 16-stud-wide increments too: 16×32, 32×32, 48×32, and so forth. You can, of course, create larger buildings by combining baseplates.

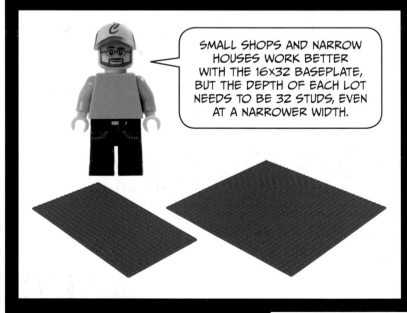

SMALL SHOPS AND NARROW HOUSES WORK BETTER WITH THE 16×32 BASEPLATE, BUT THE DEPTH OF EACH LOT NEEDS TO BE 32 STUDS, EVEN AT A NARROWER WIDTH.

A 16×32 plate versus a 32×32 square plate

Connecting the Buildings

Buildings are connected to one another at the base via LEGO Technic pins. You'll use four Technic bricks (part #3700) and two Technic pins (part #2780) for each connection.

Of course, you must space these Technic bricks consistently to match other buildings.

For a corner building, the placement of the Technic bricks remains the same: the 9-stud, 10-stud, 9-stud pattern shown at right.

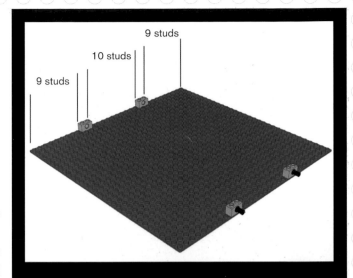

Even though you don't have a building yet, you'll want to place these Technic parts first for planning purposes.

Technic pins hold your town together. They also allow you to build houses separately and connect them when you're finished.

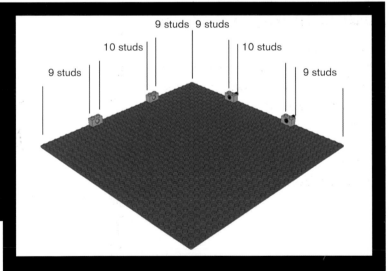

Corner buildings maintain the same connections at the same spacing, just on a different side of the plate.

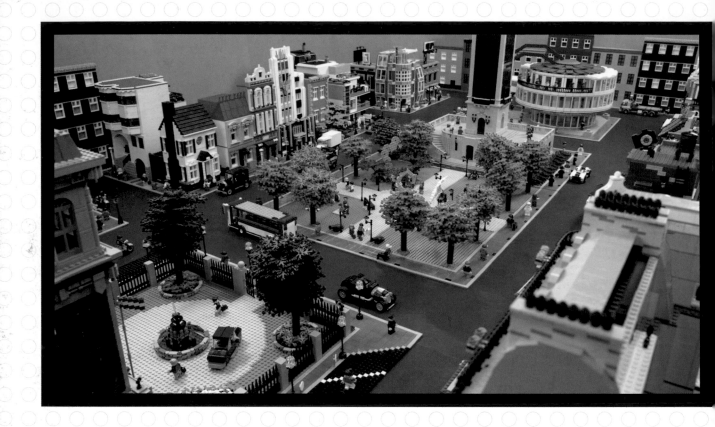

NOW LET'S START THE TOUR!

1 A Residential Neighborhood

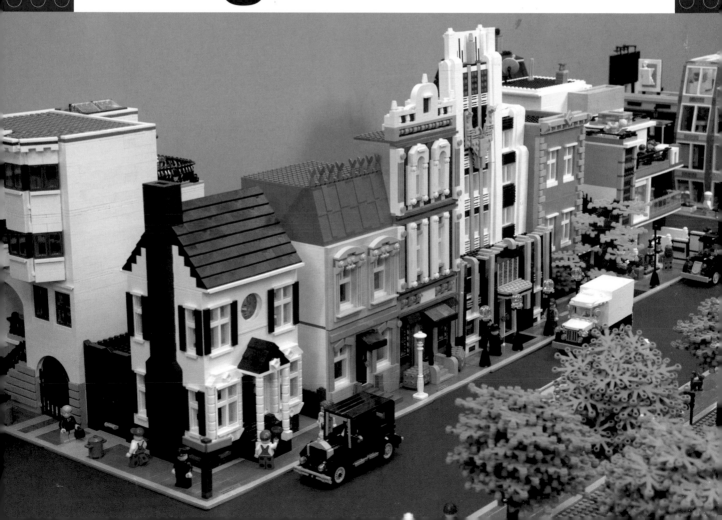

American Colonial

The American colonial style is a common sight in older cities along the East Coast. Older houses like this one don't have fancy curves. Because this house is placed on the corner, the facade and the dramatic chimney are visible to passersby. The old carriage house has been converted to a garage.

This old house was built on the outskirts of the city during the late 19th century. These small windows at street level allow natural light to pour into the basement—an important consideration in the age before electricity.

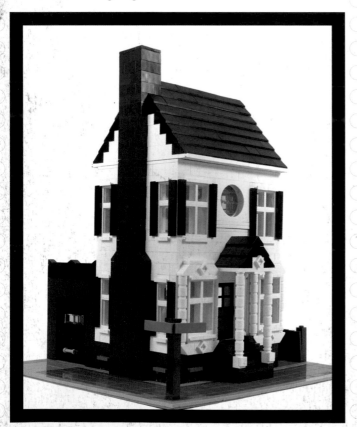

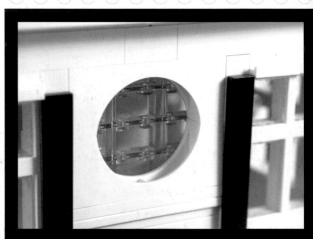

This round window was achieved with opposing arch pieces. The bottom arch isn't secured, but it stays in place.

A fancy trim adorns the front windows. The round columns on the front porch help frame the stairs and hold up the gable. There are hundreds of ways to add ornate trim to make the style your own.

There is a chimney on the side of the house. If you look closely at the eaves, you'll see where the roof separates from the second floor. The chimney is designed to segment and come off with the roof. This design makes the building easier to assemble and disassemble.

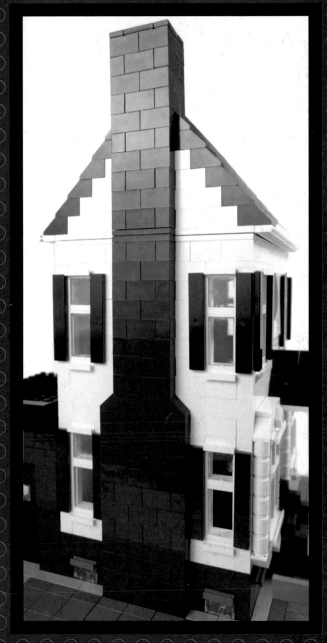

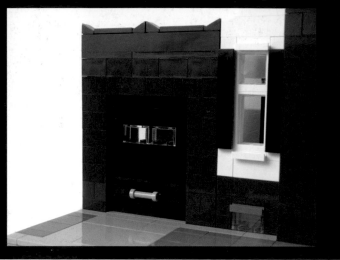
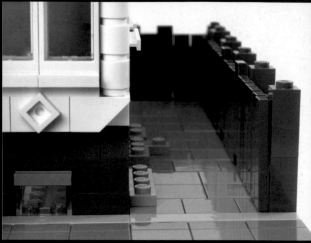

The garage out back served as a carriage house when the main house was originally built. When designing garages, you can experiment with different doors that roll up, swing out, or open inward. Or you could make a door that has more detail but doesn't open.

This house has a side yard and a backyard that are surrounded by a fence. Not all the buildings on a street have to connect to another wall. Alleys, yards, and parking lots can keep things interesting.

THIS SIMPLE STREET SIGN ADDS A LOT TO A STREET CORNER.

YOU COULD TRY ADDING SOME SIGNS OR FLIERS TO THE SIDE OF THE POST AS WELL.

I'M REALLY DIGGING THE EXTERIOR OF THIS BUILDING. LET'S LOOK INSIDE NEXT!

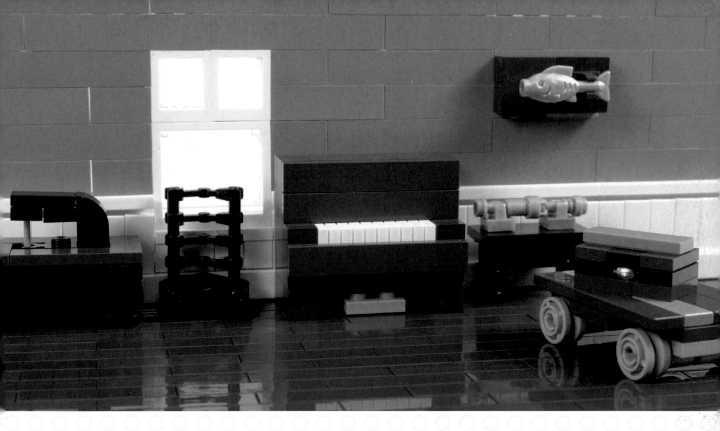

Colonial Interior

Adding details inside your houses can increase the "wow" factor of your city. You might decorate the house to reflect the inhabitants' interests or a certain time period. In this build, you can see some nice antiques and details that look at home in this old house, like the sewing machine table, the piano, and the wainscoting on the wall.

WHAT OTHER ANTIQUES WOULD BELONG IN A HOUSE LIKE THIS?

LET'S SEE HOW TO BUILD THE PIANO NEXT.

Piano

1

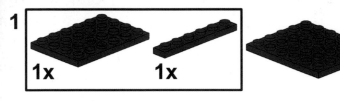

1x 1x

2

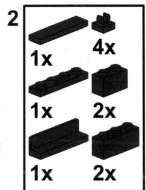

1x 4x

1x 2x

1x 2x

3

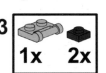

1x 2x

4

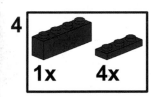

1x 4x

5

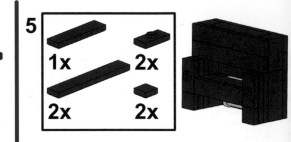

1x 2x

2x 2x

6

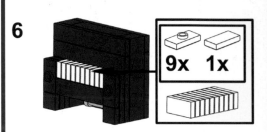

9x 1x

7

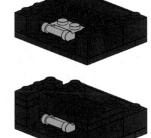

1x

1x

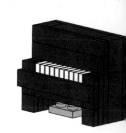
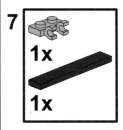

Boutique Hotel

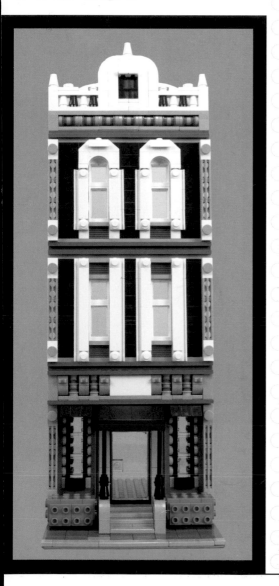

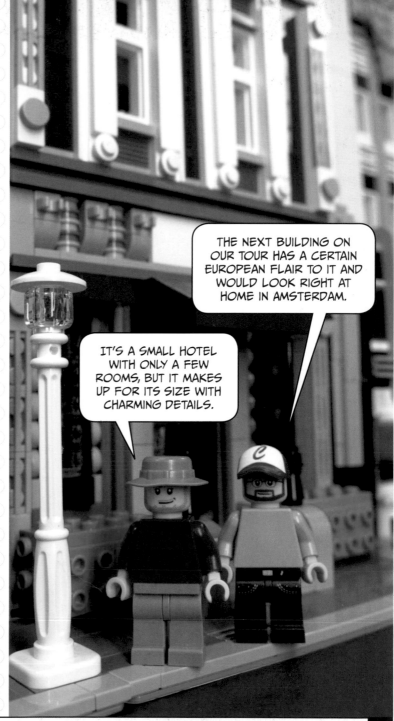

THE NEXT BUILDING ON OUR TOUR HAS A CERTAIN EUROPEAN FLAIR TO IT AND WOULD LOOK RIGHT AT HOME IN AMSTERDAM.

IT'S A SMALL HOTEL WITH ONLY A FEW ROOMS, BUT IT MAKES UP FOR ITS SIZE WITH CHARMING DETAILS.

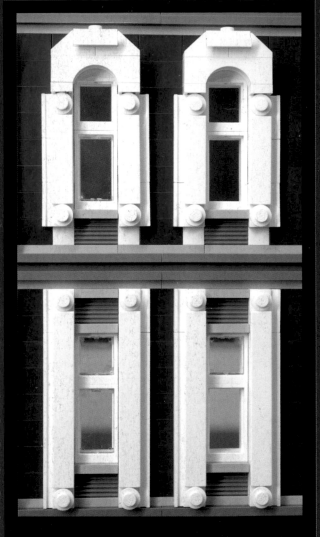

Take a look at the intricate windows on the upper levels.

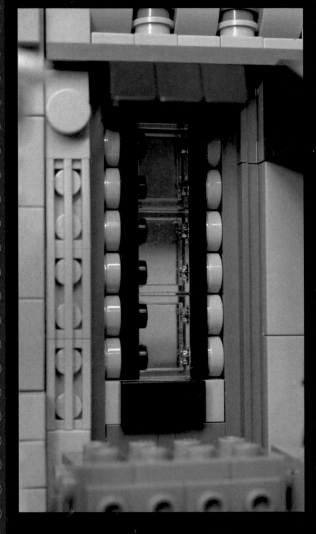

The brick-built windows on the ground floor are constructed using **SNOT** (studs not on top) techniques.

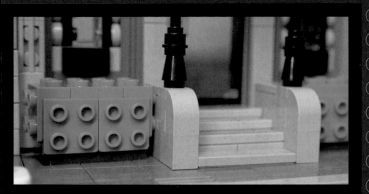

A small set of stairs leads to the first floor of this hotel. Trimmed bushes add a pop of color on each side.

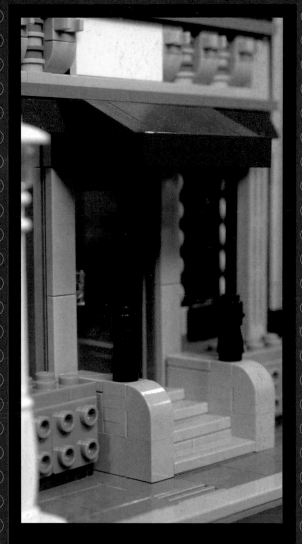

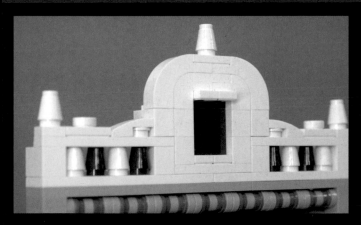

This roofline has a certain elegance that is often found in older European architecture.

The entrance to the hotel has a red awning that matches the window awnings.

Art Deco Apartment Building

The third building on our tour is an apartment building with flowing lines and lavish ornamentation that make it undeniably art deco in its architectural style.

Art deco is a style particularly suited to being built with LEGO. There are a lot of clean lines, interesting colors, and relatively simple designs.

The vertical lines on the front of this building give it a taller appearance. The light grey represents metal ornamentation on the facade. This apartment building has four lamposts in front to help light not only the sidewalk but the facade as well.

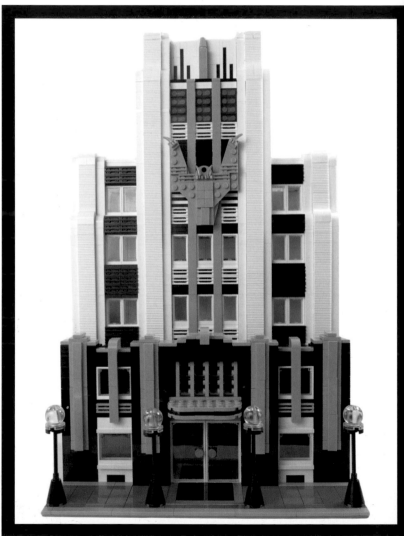

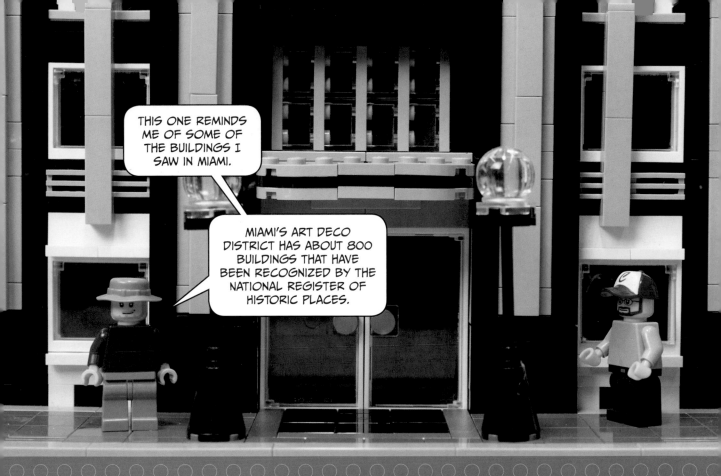

THIS ONE REMINDS ME OF SOME OF THE BUILDINGS I SAW IN MIAMI.

MIAMI'S ART DECO DISTRICT HAS ABOUT 800 BUILDINGS THAT HAVE BEEN RECOGNIZED BY THE NATIONAL REGISTER OF HISTORIC PLACES.

Check out the interesting features on the facade. The curved awning over the door and the decorated windows on each side help to create a grand entrance.

The trim on the lower section of the building is made of metal and has a stepped design, directing the viewer's eye upward to the rest of the building.

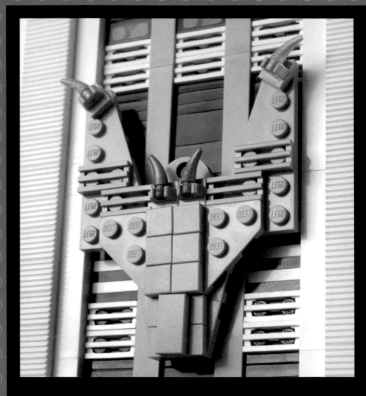

This ornate metal sculpture is typical of art deco architecture and is a grand centerpiece for this apartment building.

These vertical white columns flow from top to bottom like a waterfall. They also help tie the second story to the floors above it.

NOW LET'S CHECK OUT WHAT'S INSIDE.

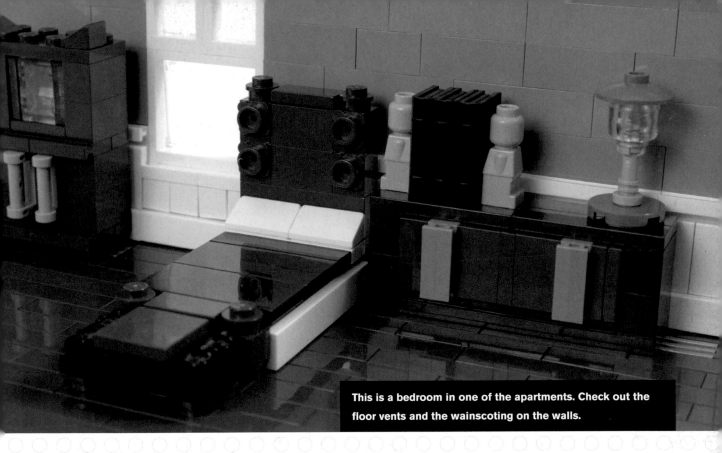

This is a bedroom in one of the apartments. Check out the floor vents and the wainscoting on the walls.

Art Deco Interior

The display cabinet, wooden bed with a skirt, and cabinet shown in this bedroom are all interesting bits of furniture and feature SNOT techniques.

LET'S LEARN HOW TO BUILD THE DISPLAY CABINET.

Display Cabinet

1
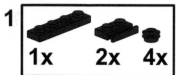
1x 2x 4x
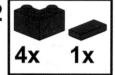

2
4x 1x
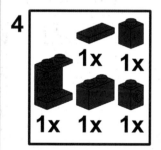

3
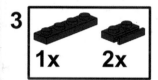
1x 2x

4

1x 1x
1x 1x 1x

5
1x
1x 1x

6
2x
1x 2x
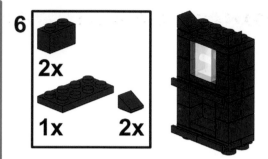

7
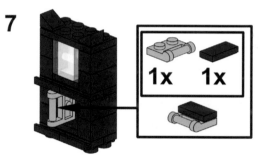
1x 1x

8
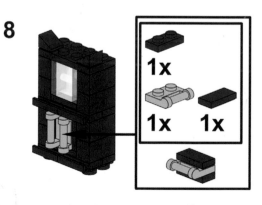
1x
1x 1x

Italianate Row House

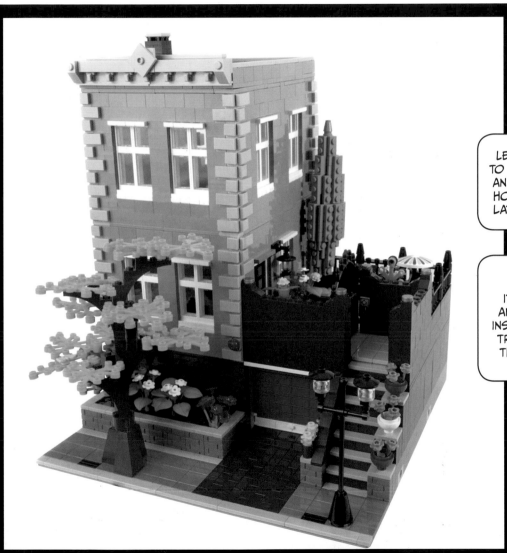

LET'S WALK DOWN TO THE NEXT HOUSE, AN ITALIANATE ROW HOUSE BUILT IN THE LATE 19TH CENTURY.

MY FAVORITE PARTS OF THIS HOUSE ARE ITS OUTDOOR SPACES AND LANDSCAPING. FOR INSTANCE, CHECK OUT THE TREE ON THE SIDEWALK, THE PLANTER BOX, AND THE LAMPPOST.

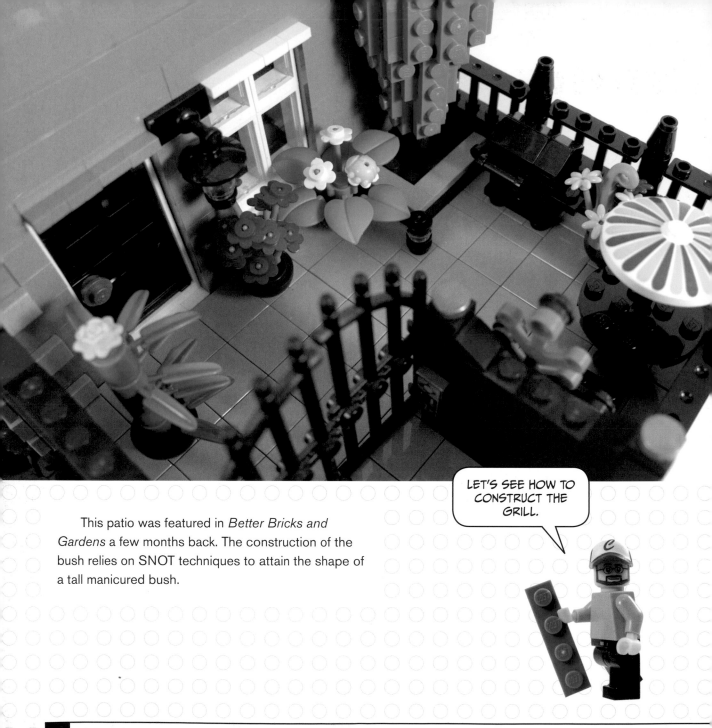

This patio was featured in *Better Bricks and Gardens* a few months back. The construction of the bush relies on SNOT techniques to attain the shape of a tall manicured bush.

LET'S SEE HOW TO CONSTRUCT THE GRILL.

Barbecue Grill

1
1x 4x

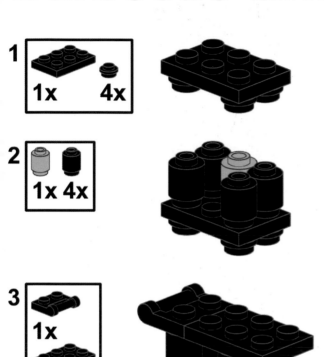

2
1x 4x

3
1x
1x

4
2x
1x

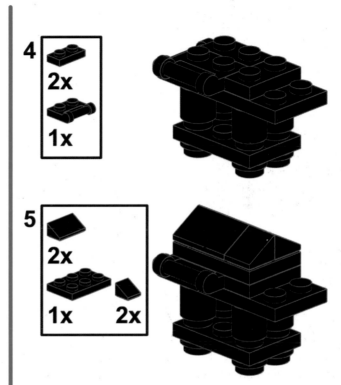

5
2x
1x 2x

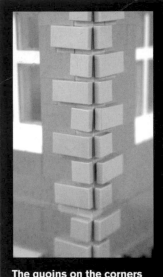

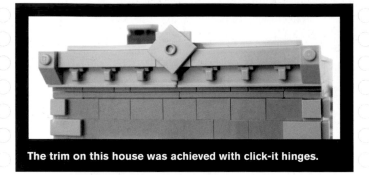

The trim on this house was achieved with click-it hinges.

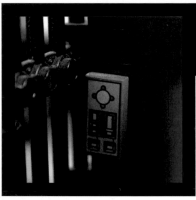

A security keypad unlocks the gate to the porch.

The quoins on the corners are connected by bricks with a stud on the side. Real-life quoins can be either aesthetic or structural.

THIS DOUBLE-HEADED LAMPPOST SHOWS THAT THIS HOUSE IS IN A FANCIER PART OF TOWN.

I WANT TO GO CHECK OUT THE INTERIOR, SO LET'S HEAD INSIDE.

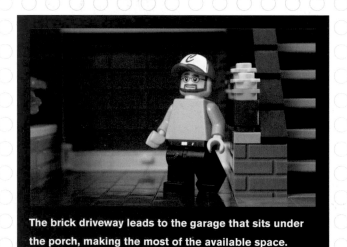

The brick driveway leads to the garage that sits under the porch, making the most of the available space.

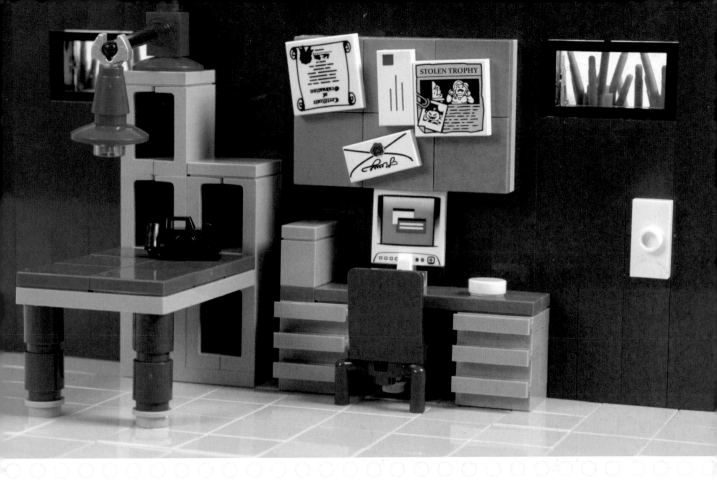

STOLEN TROPHY

Row House Interior

The basement of this house includes a home office. In this setup, the single brick with the tile on top of the desk is a desktop computer, and the round white tile is a mouse.

Check out the stand-up workstation with shelves. It looks like the homeowner is a photographer and uses the light with the swing-out arm to illuminate the work area. Note also the small, high windows. That's the style of windows you often find in older basements.

These are just a few options for a home office. What kind of desk can you create? The type of desk may depend on what type of work the person is doing.

Modern House

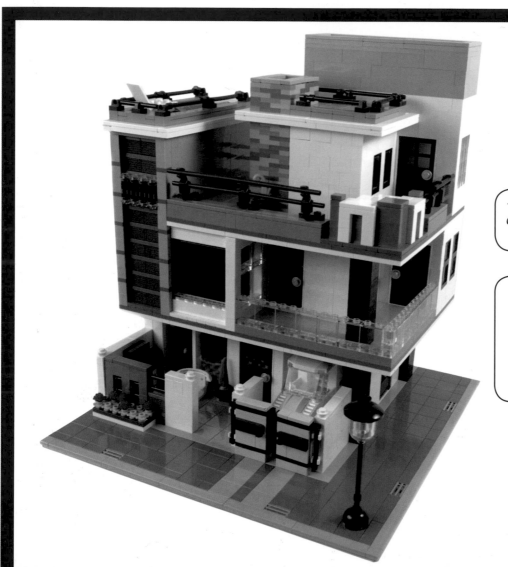

THE LAST HOUSE ON OUR TOUR IS BUILT IN A MODERN STYLE.

IT USES SEVERAL DIFFERENT TYPES OF BUILDING MATERIALS, BUT YOU CAN SEE FROM ONE STORY TO THE NEXT HOW THOSE MATERIALS ARE USED TO TIE THE WHOLE BUILDING TOGETHER.

Note the use of cantilevers in this building. We recently took a tour of Frank Lloyd Wright's *Fallingwater*, and he made heavy use of cantilevers in that house. A *cantilever* is a portion of a bridge or building that extends away from the main structure but is fixed only on one end or in the middle. Think of a bridge with a single supporting column in the middle. The roadway on either side of the supporting column balances the load.

Modern architecture often features straight lines, and on this house, the lines are both horizontal and vertical, starting down here in the carport.

This multicolored stone chimney serves as an accent to help break up the white walls. It is both decorative and functional.

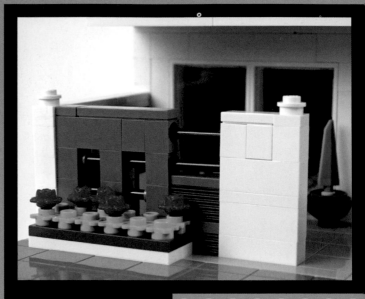

This concrete wall is broken up by metal bars.

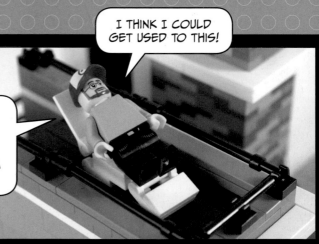

THIS HOUSE, LIKE MANY MODERN HOUSES, IS ALL ABOUT MULTIPLE LEVELS, INCLUDING THIS ROOFTOP HANGOUT WITH A LOUNGE CHAIR.

I THINK I COULD GET USED TO THIS!

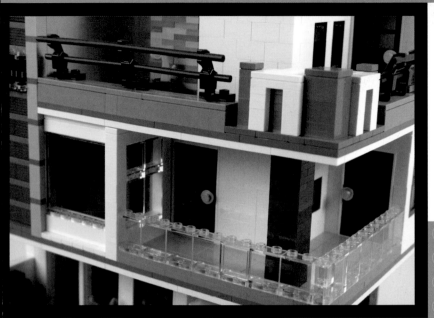

This house has several levels and features exterior walkways to help connect different parts of the house. The red brick columns help hold up those walkways but also stand out as accents because of the stark contrast of color. The red brick columns start on the first floor and continue on to the second floor, helping to tie the first floor to the second floor visually.

This metal railing on the upper floor provides an almost commercial or industrial look to the house. You can also see black metal railings on the first floor and on portions of the roof. The repeated use of this material helps create a visual connection from the first floor to the third floor and the roof.

This tall, vertical section features a different color and ornamental lights to help draw the viewer's eye.

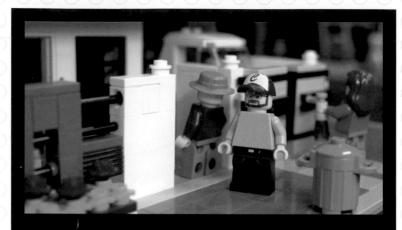

Details on the sidewalk, like planters and trash bins, create a realistic, lived-in look.

SPEAKING OF LIGHT, THIS LAMPPOST IS YET ANOTHER WAY OF MAKING THIS HOUSE AND THE CITY UNIQUE.

THE OUTSIDE LOOKS GREAT, BUT I WANT TO GET A PEEK AT THE TYPE OF FURNITURE THAT WOULD BE IN A HOUSE LIKE THIS.

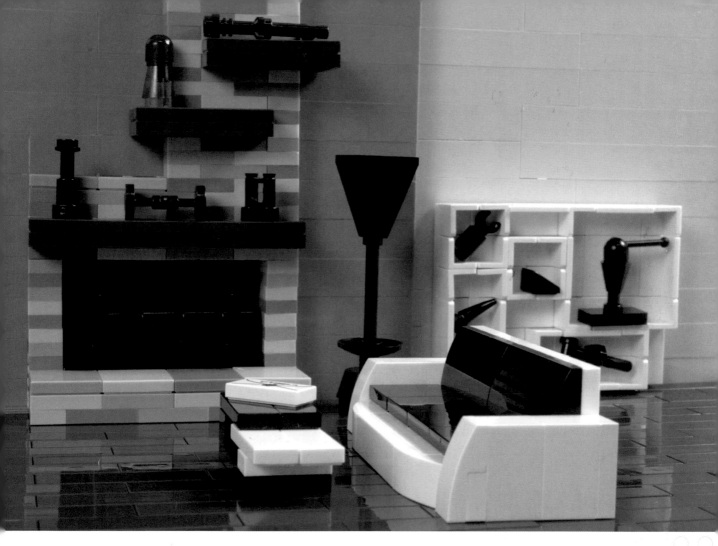

Modern Interior

The modern house's interior features two different colors on the walls. They're both neutral colors, which is typical of modern interiors, and there's a clean split that helps define where one room ends and another begins.

The floating shelves on the fireplace and the open display shelves showcase decorative objects that are all about completing a look. The sofa, lamp, and coffee table all have a similar streamlined look and color scheme. The coffee table has different levels and colors, just like the house.

Let's see how to build this sleek couch.

Modern Couch

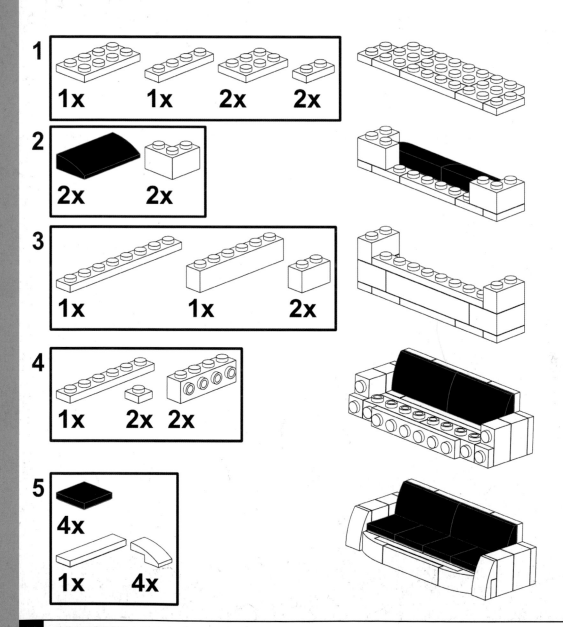

1. 1x 1x 2x 2x

2. 2x 2x

3. 1x 1x 2x

4. 1x 2x 2x

5. 4x 1x 4x

Staircase Entrance

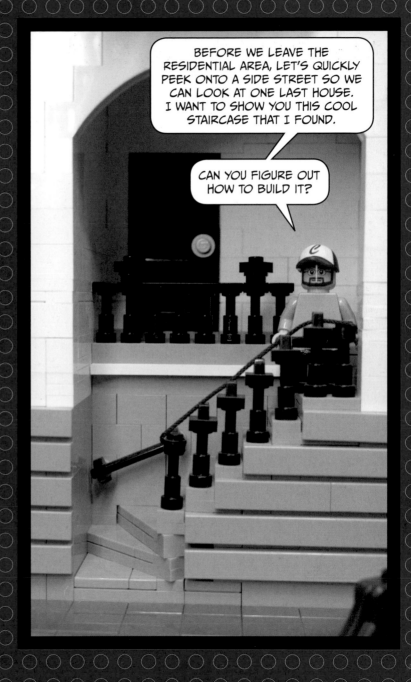

2 A Commercial Neighborhood

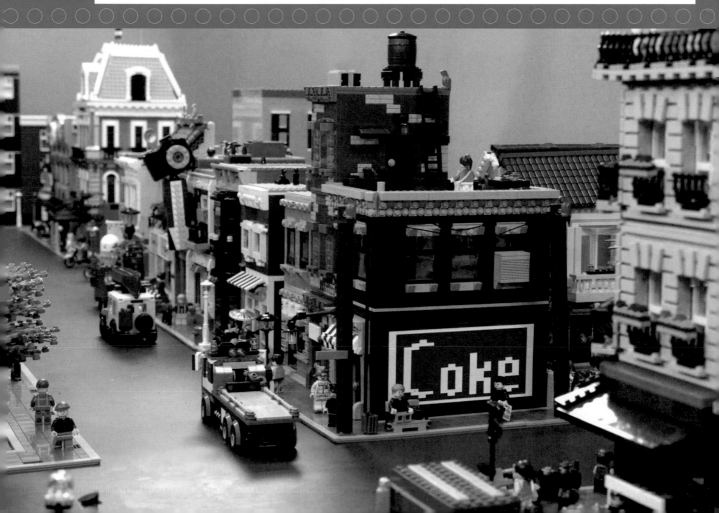

Corner Store

The first two buildings that make up our commercial neighborhood occupy the same baseplate and are located on the corner of the block. The corner store has an apartment on the second floor, and the narrow building next door could be used as apartments or offices.

The side of this corner convenience store has a popular advertisement painted on the side.

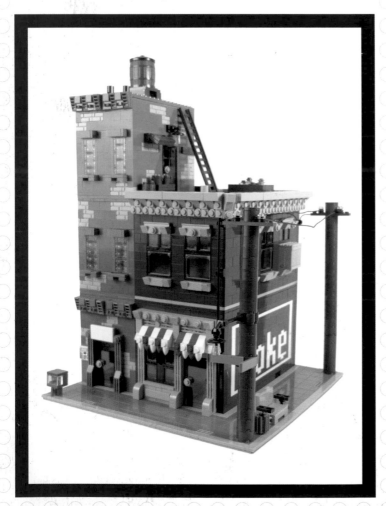

AN ADVERTISEMENT ON THE SIDE OF YOUR BUILDING CAN HELP PLACE THE BUILDING IN A CERTAIN TIME PERIOD.

A COLORFUL AD— OR EVEN GRAFFITI— REALLY HELPS BRING LIFE TO AN OTHERWISE BORING WALL.

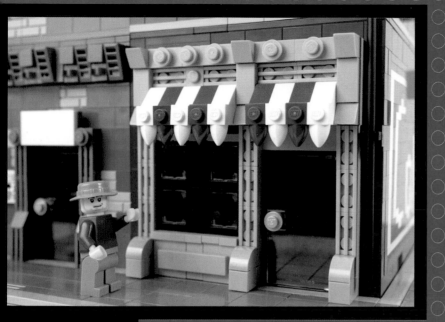

The shopfront features
an ornate facade and a
striped awning.

From street level, the corner
trim looks like it's floating. But
check out how it's attached.

On the sidewalk, a bench and a trash can help fill out the street corner.

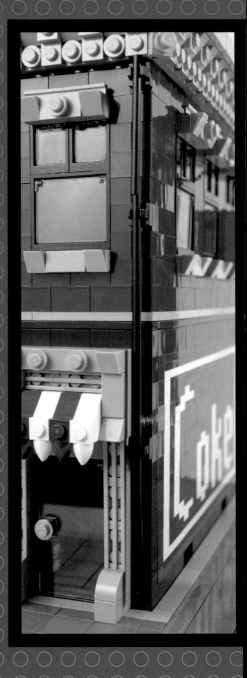

THIS DOWNSPOUT RUNNING FROM TOP TO BOTTOM ADDS A TOUCH OF REALISM TO THE FACADE.

IT'S MADE OF SEVERAL SHORTER PIECES, SO THE LEVELS CAN STILL BE TAKEN APART.

You can have electric poles running along your sidewalks—and don't forget the lights and street signs that are often attached to the poles.

An AC unit is an often-overlooked detail that can be found in many windows across the city. Consider the time period of your city to help determine what would be appropriate.

These power lines feature glass insulators as a nice detail.

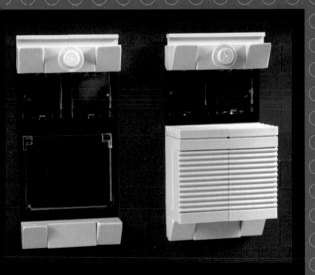

AC units add realism to any building.

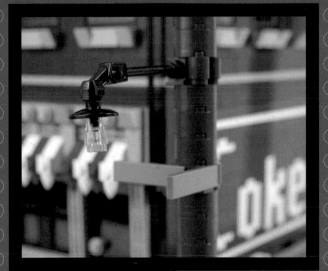

This utility pole includes a streetlight and signs.

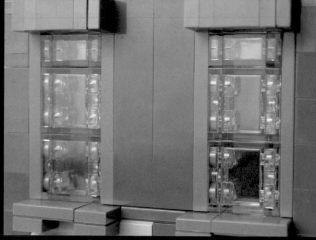

This rooftop garden adds flair and personality to the building. It brightens up the roof and provides a much-needed "yard" for city dwellers.

Sometimes you might be missing a prebuilt window in the color you want, which forces you to get creative. Take a closer look at these windows made out of clear bricks. The windows are built almost entirely sideways.

THIS GREY BRICK PATTERN WHERE THE PAINT HAS PEELED AWAY SHOWS THE AGE OF THE BUILDING.

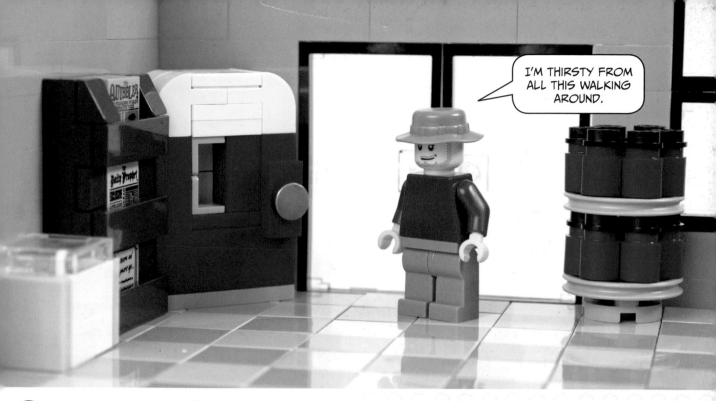

Corner Store Interior

This store has a soda machine, a newspaper rack, an ice cream chest, and a turnstile display holding motor oil.

The vintage soda machine will look great if the setting of your town is the '30s or '40s. Let's see how to build it.

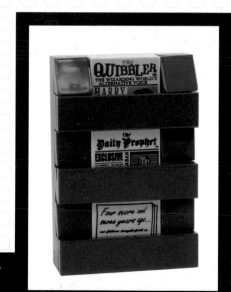

A newspaper rack is a great way to display your decorated tiles.

Soda Machine

1

1x

1x

1x

1x

1x

1x

1x

2

1x 2x

3

1x 1x 2x

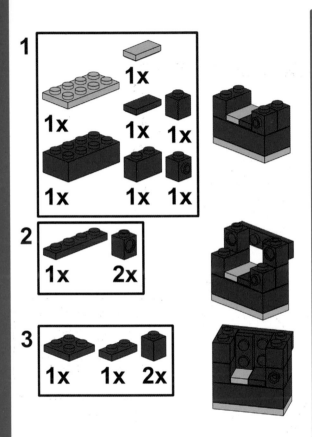

4

1x 1x 1x 2x 1x

5

2x 4x

1x 1x

Small Shops with Alley

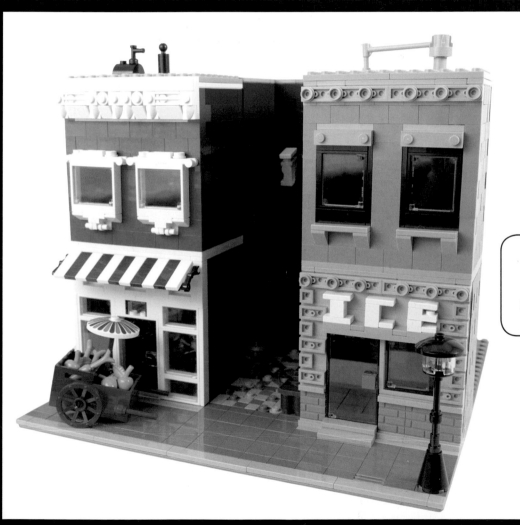

THESE TWO STORES HAVE AN ALLEY BETWEEN THEM AND FEATURE SEVERAL NEAT ARCHITECTURAL DETAILS.

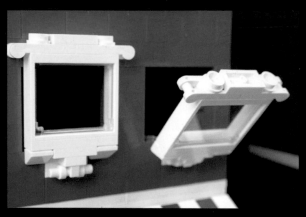

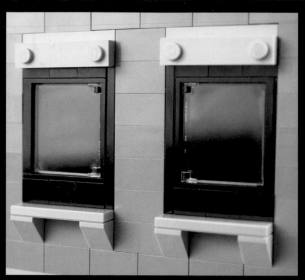

These white windows were built upside down, and the black ones are mounted sideways.

The lamppost on the sidewalk has an old cast-iron style.

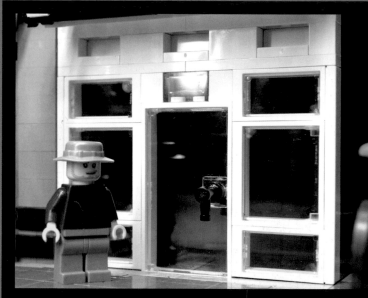

The windows surrounding the front door are mounted sideways and help create a new look.

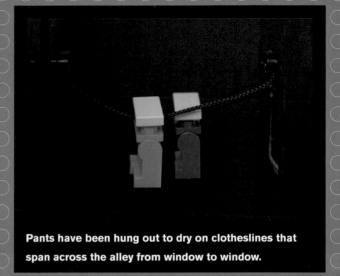

Pants have been hung out to dry on clotheslines that span across the alley from window to window.

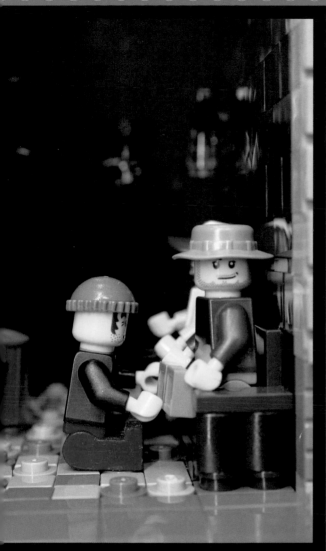

The alley between the two buildings has a shoeshine stand. The old cobblestone surface of the alley wasn't replaced at the same time as the newer sidewalk.

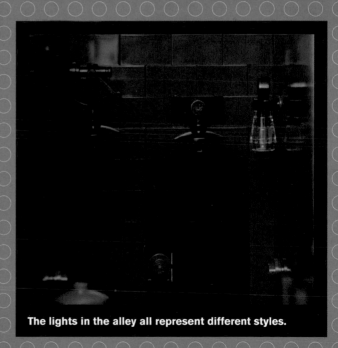

The lights in the alley all represent different styles.

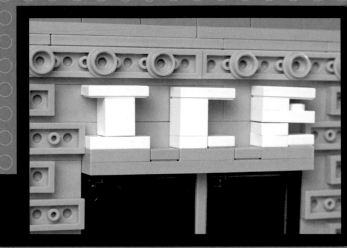

This ice sign features another way of creating letters. The backward plates around the sign create the look of a carved stone trim.

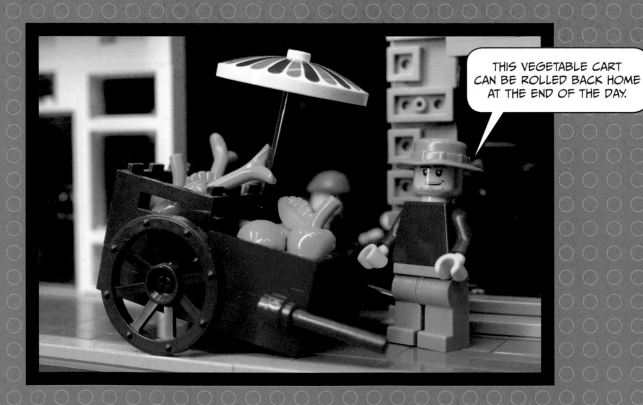

THIS VEGETABLE CART CAN BE ROLLED BACK HOME AT THE END OF THE DAY.

Shop Interiors

Check out the furnishings inside these shops!

SO MANY CHOICES... THIS DVD RENTAL KIOSK WOULD LOOK GREAT EITHER IN A STORE OR OUT FRONT ON A SIDEWALK.

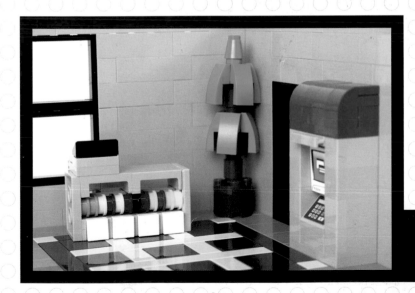

A decorative plant, an ATM, and a checkout counter, complete with a candy display, round out the interior.

DVD Rental Kiosk and Sign

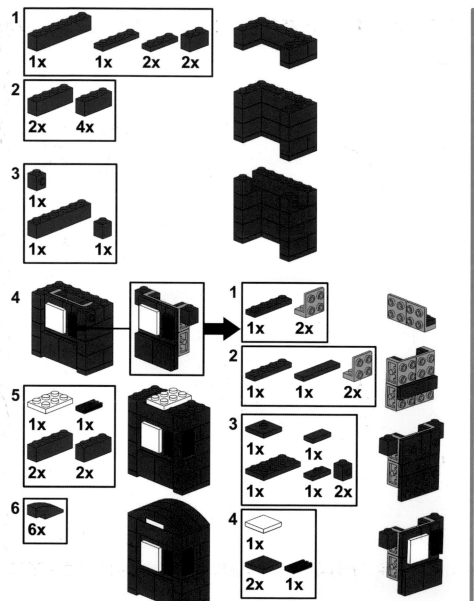

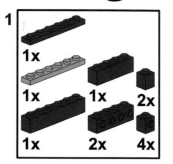

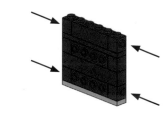

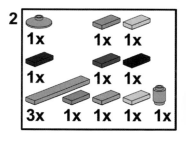

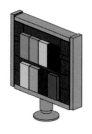

Toy Store and Camera Shop

Our next stop is a toy store that shares a baseplate with a camera store. There are some interesting techniques used in both of these stores, so pay close attention.

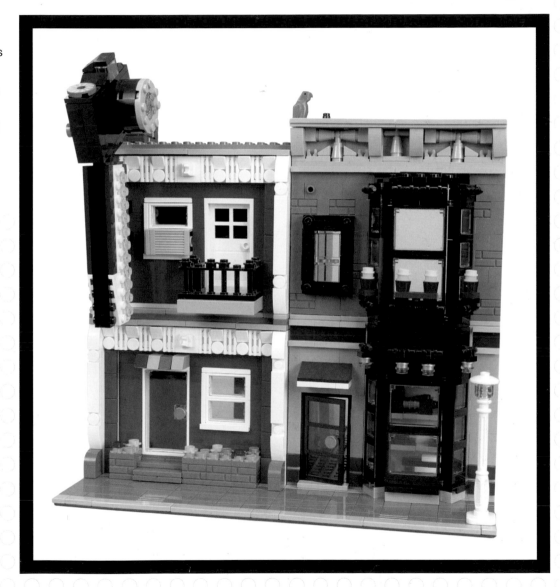

These small flowerpots line the second-story window above the toy store. These planters provide a spark of color to contrast against the black windows.

The toy store's window display shows off a slinky dog, some cars, and a fire truck. Children will just *have* to go inside when they see that from the street.

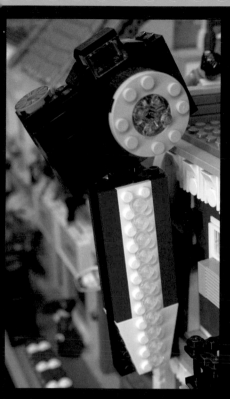

The sign with a yellow arrow and flashing lights helps draw in customers to the camera store once the sun goes down.

This building was made using SNOT techniques. The lower level is built upside down, including the stairs and the flower boxes out front. The windows are built sideways.

This balcony juts out from the building and has a door that saves space by opening inward.

Japanese Restaurant and Board Shop

A Japanese restaurant and board shop make up the next set of buildings.

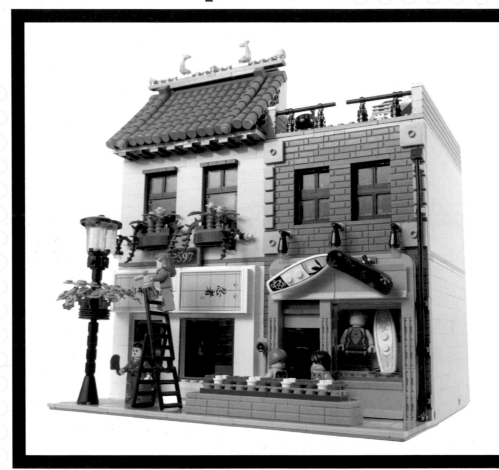

OUT FRONT, THIS SIDEWALK PLANTER GIVES THE FEELING OF A REJUVENATED DOWNTOWN AREA.

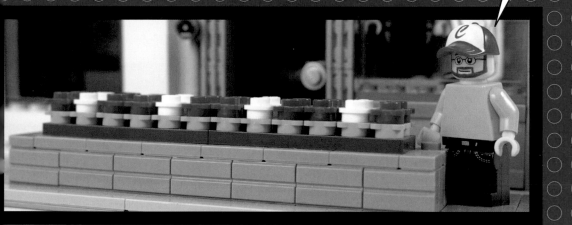

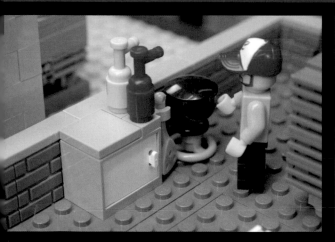

This rooftop BBQ patio with seating is the perfect place for the employees of the board shop to hang out.

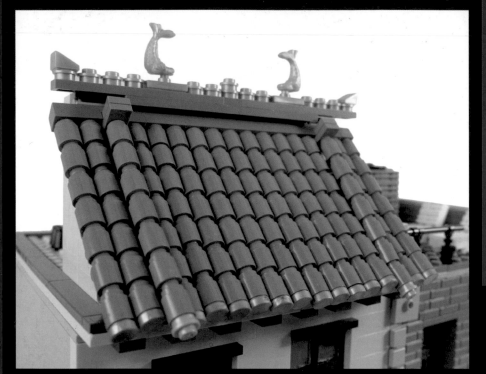

The restaurant roof features traditional characteristics that help you identify it before even setting foot inside.

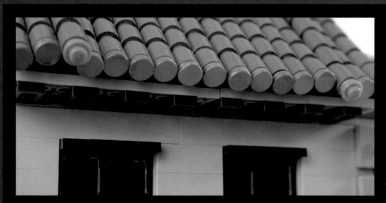

This restaurant has some unique architectural elements, especially the roof, which uses round bricks for clay tiles.

CHECK OUT THESE FANCY FLOWER BOXES WITH VINES CRAWLING DOWN THE FRONT OF THE BUILDING.

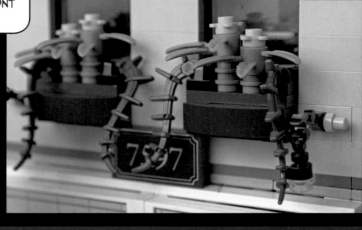

Including an electricity meter and a roof-top AC unit is a great way to add realism to a building.

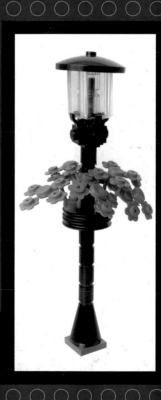

Everything in this area of the city has been updated, including this lamp-post with a flower basket on it.

Board Shop Interior

Various fixtures inside the board shop give it a realistic look.

These display lights even include wiring.

THE WIRING IS MADE USING RUBBER BANDS.

Find creative ways of displaying the store's merchandise, such as this rack that holds snow goggles. What other accessories fit in those sloped grate pieces?

Japanese Restaurant Interior

As we step inside the Japanese restaurant, we immediately see that the décor and furniture fit the theme.

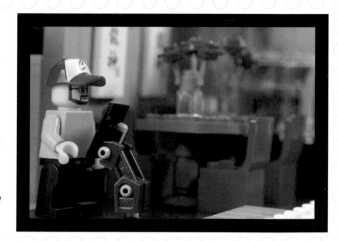

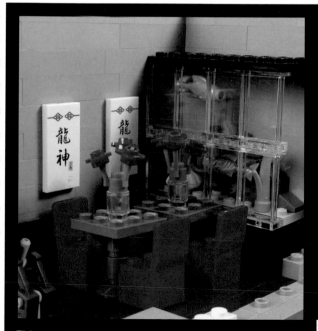

This restaurant has an aquarium and some Japanese tiles on the wall for decoration, and those chairs with silk slipcovers are a nice touch.

Ice Cream Shop

THIS IS AN OLDER BUILDING THAT HAS HAD MANY BUSINESSES IN IT OVER THE YEARS, AND NOW IT'S AN ICE CREAM SHOP.

THE BRIGHT ACCENT COLORS MAKE IT LOOK LIKE A FUN AND INVITING PLACE TO ENJOY A CONE WITH FRIENDS OR FAMILY.

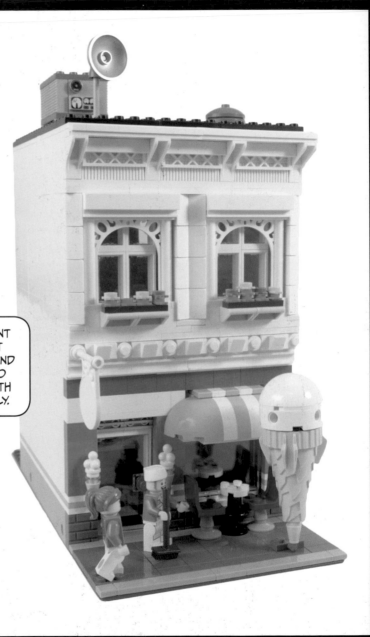

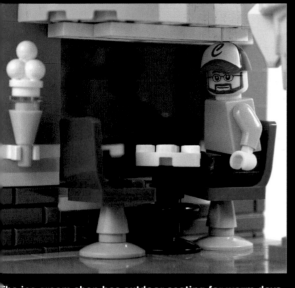

The ice cream shop has outdoor seating for warm days.

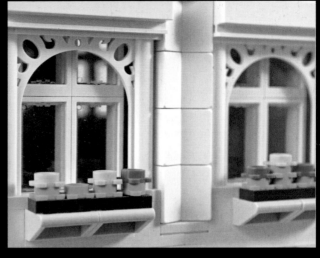

These white pieces help create a fancy trim around the windows.

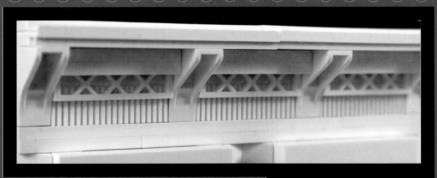

These arches and fences form a fancy roofline to cap off the building's facade.

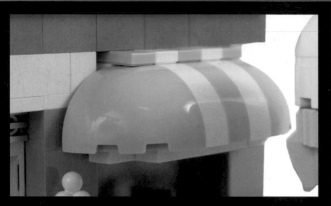

This awning was created to have two white stripes with a green stripe between them. Offsetting was used to achieve this effect and to center the awning over the window.

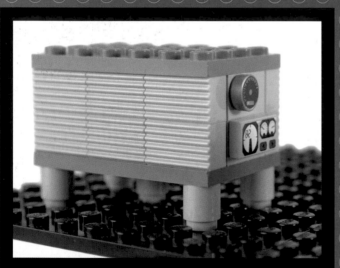

This huge AC unit means business and keeps the ice cream shop nice and cold. A good way to research AC units is to look at rooftops on Google Maps to get an idea of how many or what sizes there are for different buildings.

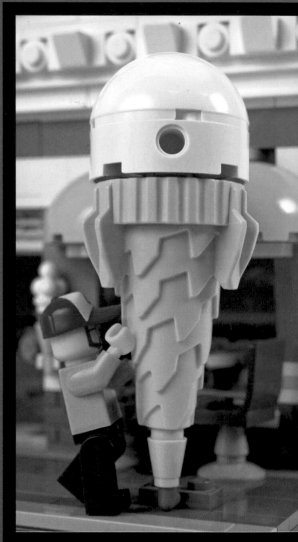

This huge ice cream cone draws in customers and leaves no doubt as to what type of shop this is.

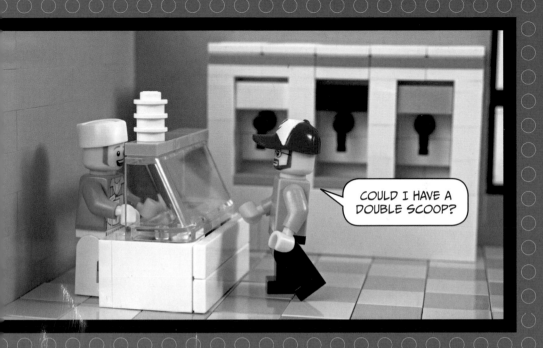

COULD I HAVE A DOUBLE SCOOP?

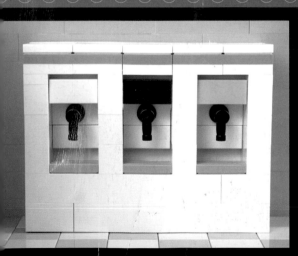

The frozen-yogurt machine has three different flavors to choose from.

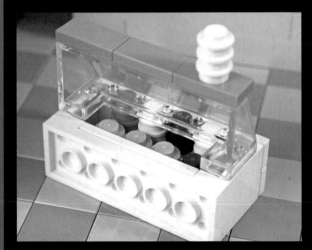

You could also build a toppings bar for all this ice cream.

Toppings Bar

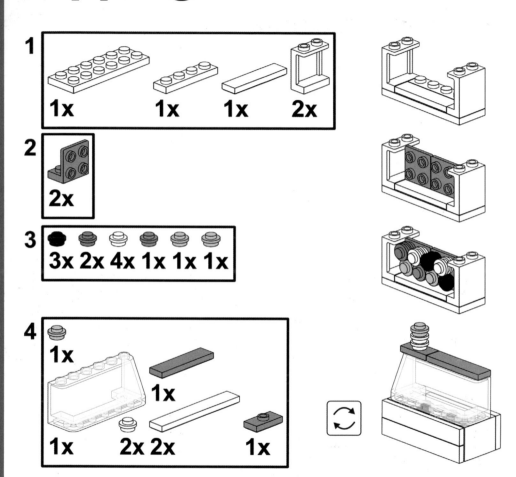

Small Vendor Stalls

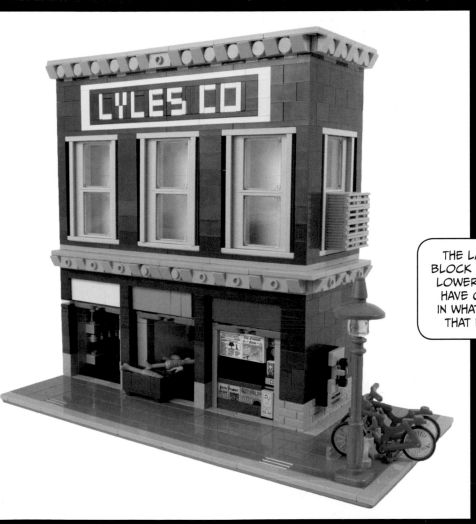

THE LAST BUILDING ALONG THIS BLOCK HAS SEVERAL SHOPS IN THE LOWER LEVEL. THE THREE STALLS HAVE OPENED UP FOR BUSINESS IN WHAT WAS AN OLD WAREHOUSE THAT BELONGED TO LYLES CO.

These stall shops could have just about anything for sale. This one is a newsstand.

These doors can be lowered to close the shop.

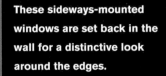

These sideways-mounted windows are set back in the wall for a distinctive look around the edges.

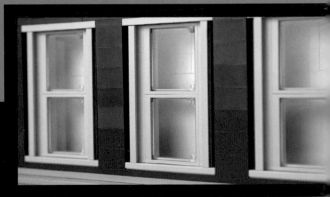

Window

Insert the window inside of the frame and push until the window is flush with the front of the building. It will be sticking out in the back, as shown in the third image.

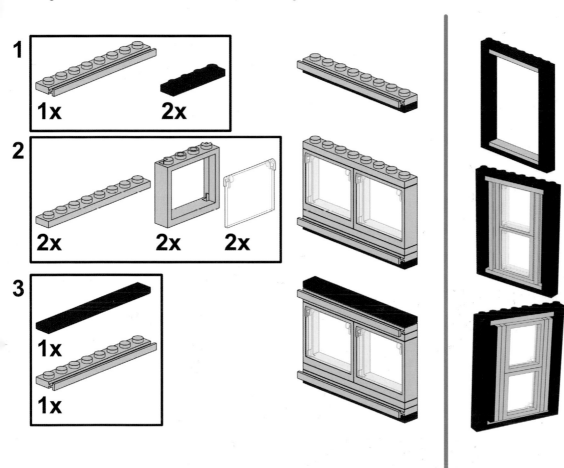

1
1x 2x

2
2x 2x 2x

3
1x
1x

THIS OLD PAY PHONE CREATES AN INTERESTING OBJECT ON THE EXTERIOR WALL AND HELPS TO DATE THE BUILDING.

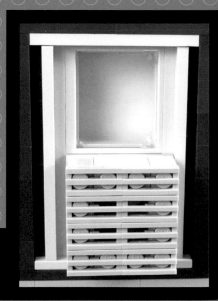

THIS BIKE RACK KEEPS BIKES OFF THE SIDEWALK.

This white-on-black design has a vintage look and is a great choice if you want a sign on your building.

This sideways-mounted window AC unit is big enough to cool the upper level of this building.

Caribbean Restaurant

The next stop on our tour is this colorful Caribbean restaurant. It's surrounded by palm trees to provide atmosphere.

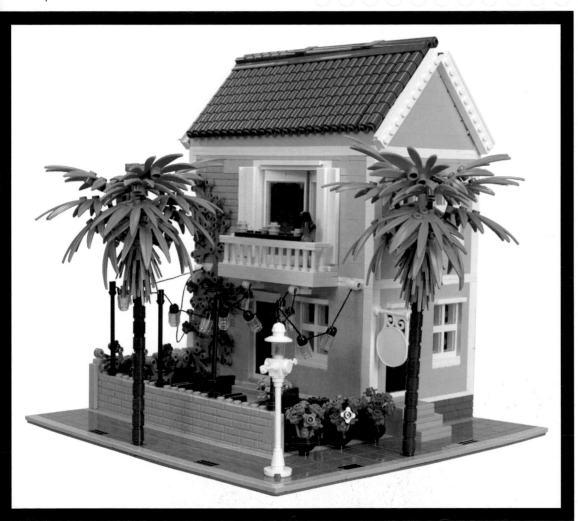

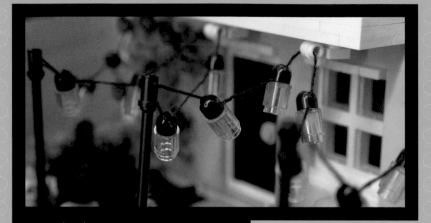

These hanging lights look great at night and provide ambience for the outdoor eating area.

The restaurant has ivy growing up the side with some nice flowers on it. It is easier to add the bricks with a stud on the side while you are building, so planning ahead is helpful if you want to add elements like this to your own walls.

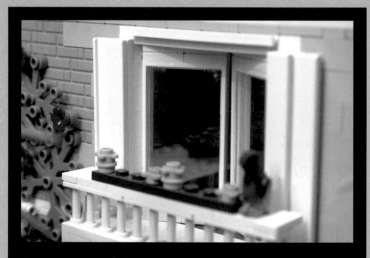

This second-story balcony features two inverted doors to make more space on the balcony itself. Hinges made it possible.

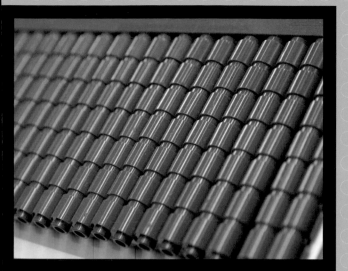

All these rows of dark orange 1×1 round bricks make this clay roof look fantastic.

Don't forget to add some color and vegetation to your sidewalks.

This palm tree mimics the look of a real palm with leaves of different colors. A black tube runs through all the round 1×1 bricks to make the tree trunk sturdy.

Parisian Corner Café

This beautifully crafted Parisian building is loaded with architectural details from a bygone era. It features a restaurant and a shop on the ground floor.

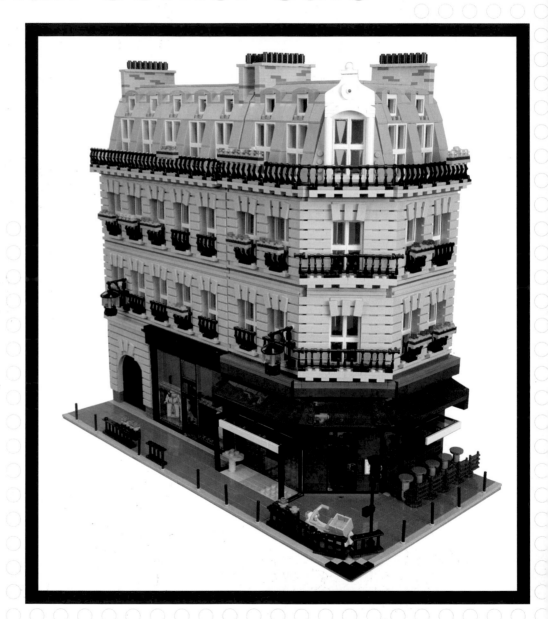

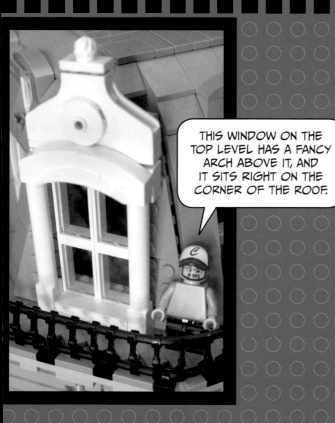

THIS WINDOW ON THE TOP LEVEL HAS A FANCY ARCH ABOVE IT, AND IT SITS RIGHT ON THE CORNER OF THE ROOF.

These railings are made from a bar and droid arms. They have planters on top as well.

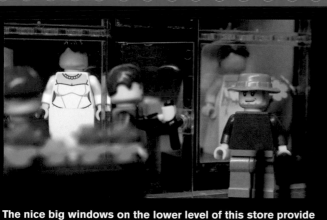

The nice big windows on the lower level of this store provide a way for passersby to see the dresses inside.

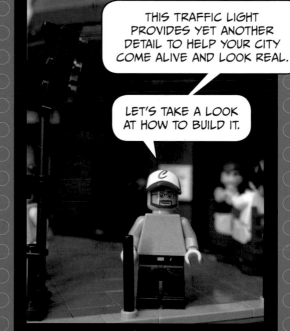

THIS TRAFFIC LIGHT PROVIDES YET ANOTHER DETAIL TO HELP YOUR CITY COME ALIVE AND LOOK REAL.

LET'S TAKE A LOOK AT HOW TO BUILD IT.

Traffic Light

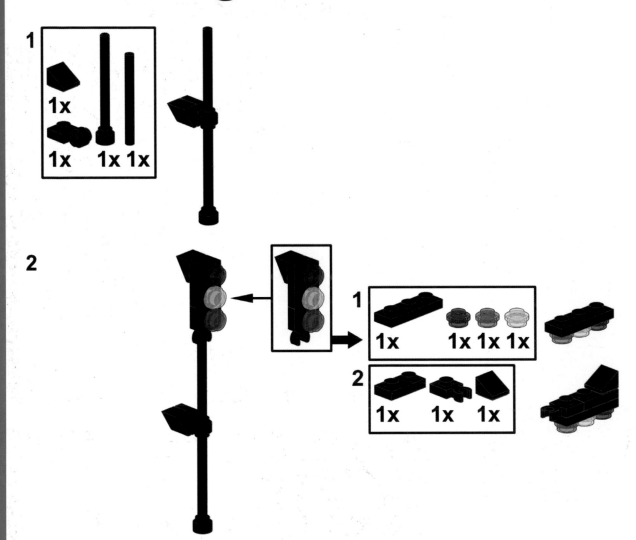

Here is a closer look at the corner awning. It wraps around the corner with the use of wedge plates.

This roof has a curve to it, just like many of the buildings found in Paris and elsewhere in Europe. Take notice of the details above the windows and the railing that goes around the whole roofline.

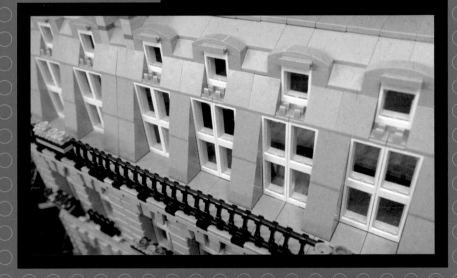

See if you can build this fancy lamp that hangs off the side of the building. Those are window panes from 1×2×2 windows.

What would a restaurant be without seating? This one has tables outside so the patrons can enjoy the nice weather.

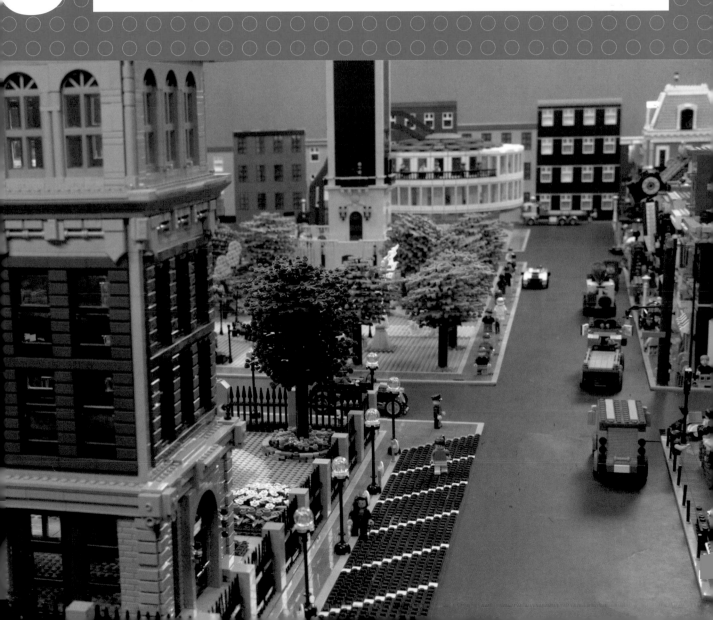

3 Public Places

Embassy

LET'S CHECK OUT THE PUBLIC PLACES THAT HELP MAKE UP A TOWN.

GOVERNMENT BUILDINGS, PARKS, MONUMENTS, AND MUSEUMS CAN REALLY ROUND OUT YOUR CITY.

OUR FIRST STOP IS THIS EMBASSY. THIS BUILDING IS MASSIVE AND HAS A STATELY COURTYARD TO MATCH ITS ELEGANT APPEARANCE.

LET'S EXPLORE THE DETAILS THAT MAKE THIS BUILDING LOOK GRAND.

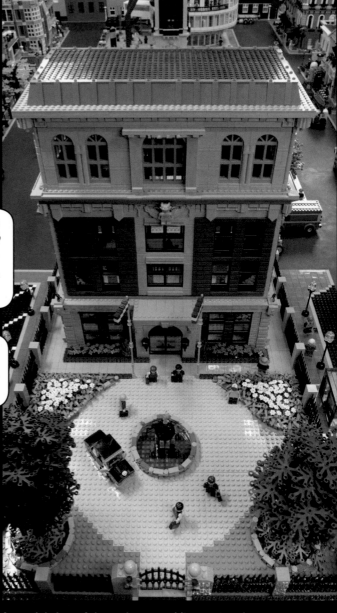

An aerial view of the embassy and its courtyard

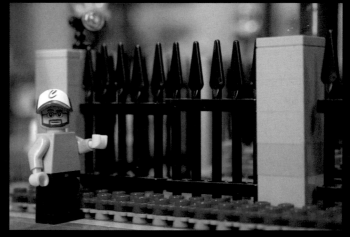

This wrought-iron fence keeps unwanted visitors out. It's made of spears and Technic liftarms.

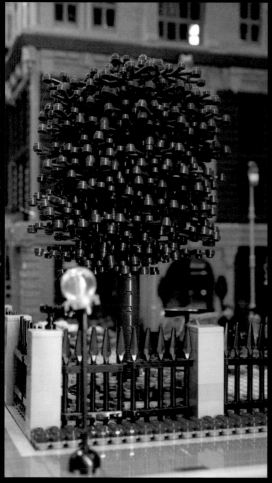

A couple of trees balance the courtyard. The foliage is created from stacks of leaf pieces around a black pipe that runs through the trunk.

Here are two different ways of creating arched windows.

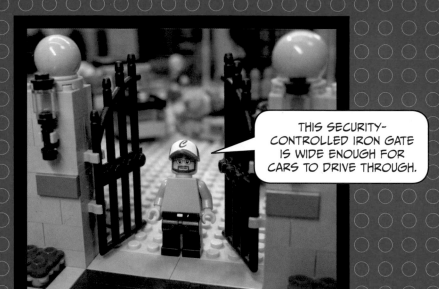

An elegant fountain adorned with gold statues sits in the middle of the circular driveway. It creates a fancy centerpiece for the courtyard.

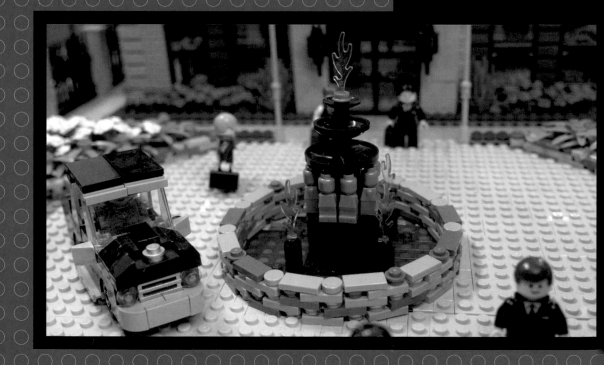

These flowers provide a spark of color against the neutral colors of the building.

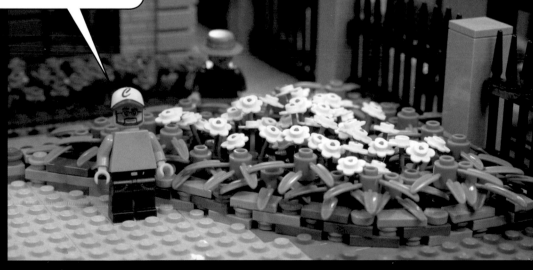

I LOVE THE CURVED STONE WALL HERE. IT REALLY LOOKS LIKE IT'S KEEPING THE PLANTS FROM GROWING OUT OF THE FLOWER BED.

Embassy Details

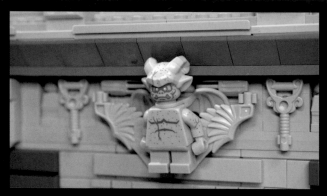

The gargoyle makes a nice decorative piece on the facade of the building.

Security cameras watch the entrance.

The corners on each level are different and feature some interesting techniques worth looking over.

The exterior of the embassy features a mix of grey stone and dark orange brick on all four sides. The symmetry of the facade adds to the elegance of the building.

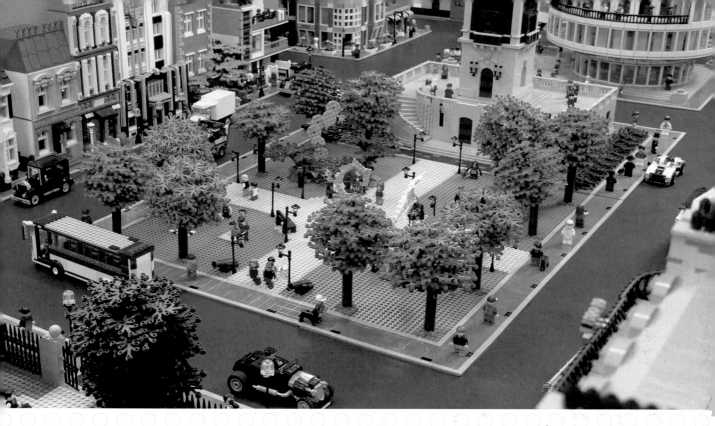

Brick City Park

This park features several sculptures, a small duck pond, and a large picnic area. Several trees outline the park's boundaries.

NOW LET'S EXPLORE THE PARK, WHERE THE INHABITANTS OF THE CITY GO TO PLAY AND ENJOY NATURE.

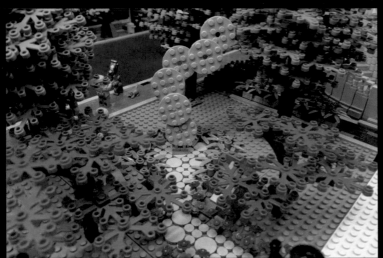

These sculptures, installed by the local art museum, beautify the city and promote the museum.

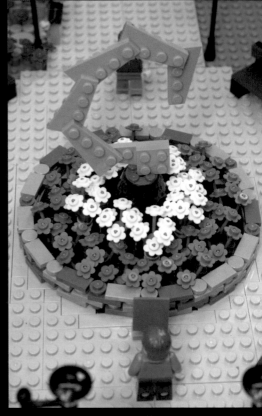

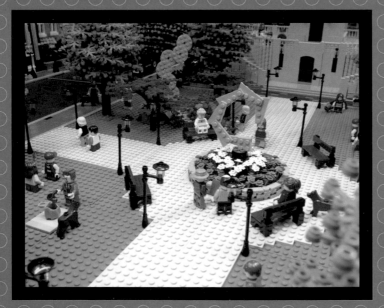

Park Details

You have almost endless possibilities for creating details in your own park. Athletic fields, basketball courts, picnic tables and pavilions, ponds, bridges, paths, and playgrounds will help create a realistic and beautiful public space. In this park, a small duck pond and mature trees provide city dwellers with a slice of nature.

Trees with plenty of foliage create shade.

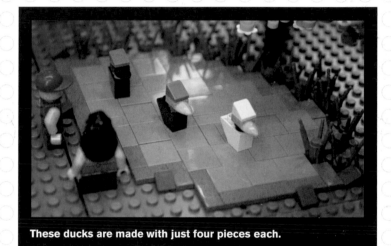

These ducks are made with just four pieces each.

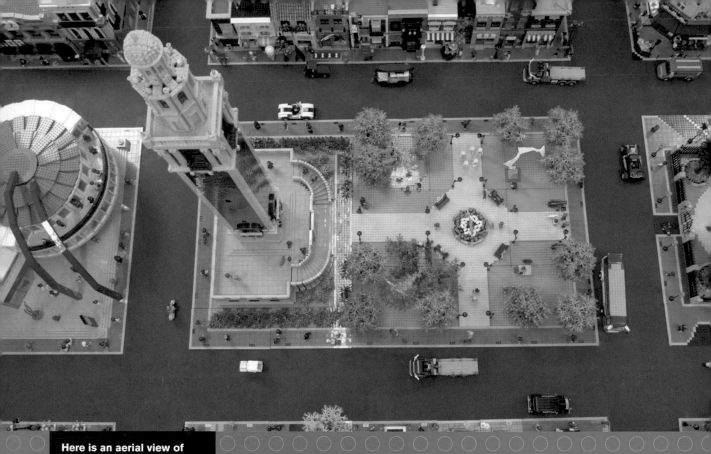

Here is an aerial view of the park surrounded by the busy city streets.

THESE CANNONS NEAR THE PARK'S ENTRANCE COMMEMORATE A BATTLE THAT TOOK PLACE NEARBY.

War Monument

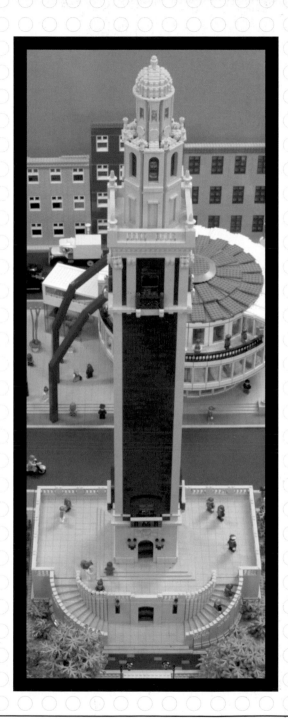

WELL, WE MADE IT THROUGH THE PARK, AND NOW WE'VE REACHED THE TALLEST STRUCTURE IN THIS CITY.

THIS ARCHITECTURAL WORK OF ART IS A MONUMENT TO THE SOLDIERS WHO FOUGHT IN WORLD WAR I. IT WAS INSPIRED BY THE CARILLON TOWER IN RICHMOND, VIRGINIA.

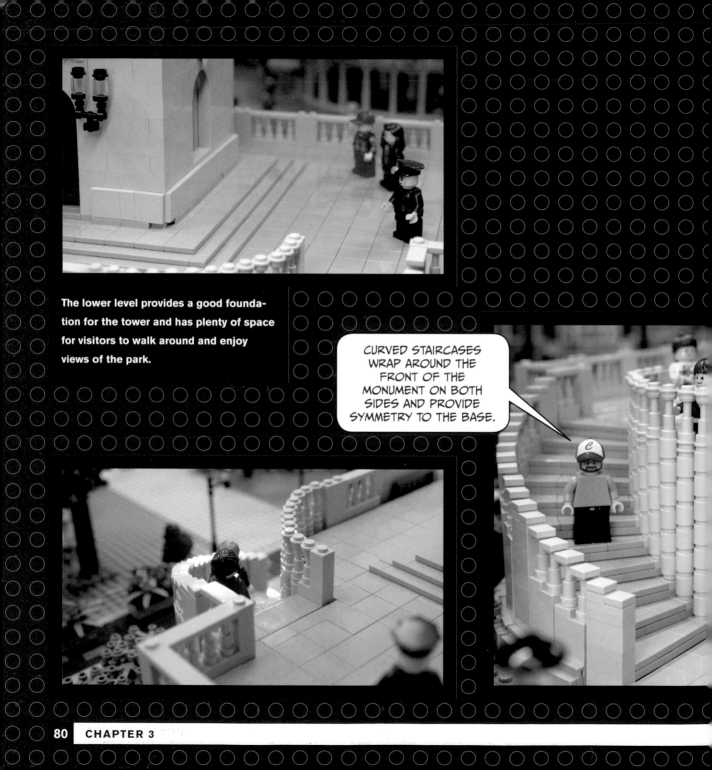

The lower level provides a good foundation for the tower and has plenty of space for visitors to walk around and enjoy views of the park.

CURVED STAIRCASES WRAP AROUND THE FRONT OF THE MONUMENT ON BOTH SIDES AND PROVIDE SYMMETRY TO THE BASE.

War Monument Details

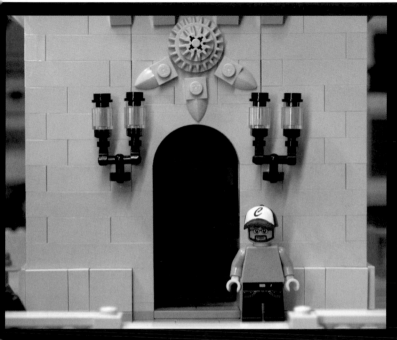

Fancy lamps and the Technic gear above the door help create the monument's intricately detailed look.

These latticed windows are created using fence pieces and **SNOT** techniques.

The Top of the Tower

Near the top of the tower, the architectural details are really packed in. Notice the railing and the columns on either side of the window.

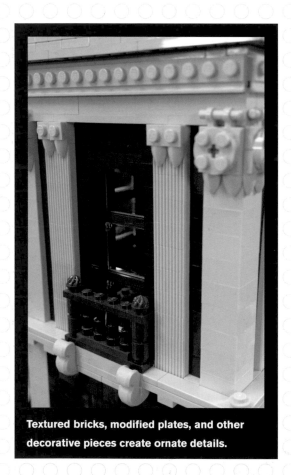

Textured bricks, modified plates, and other decorative pieces create ornate details.

Take a minute to look over all the details around the top of the monument, especially the brick-built dome.

Art Museum

FROM THE MONUMENT, WE CAN SEE THE FINAL LOCATION ON OUR TOUR: THE MODERN ART MUSEUM.

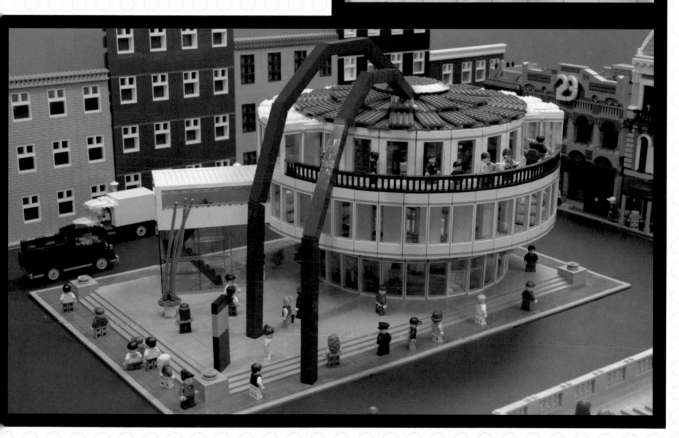

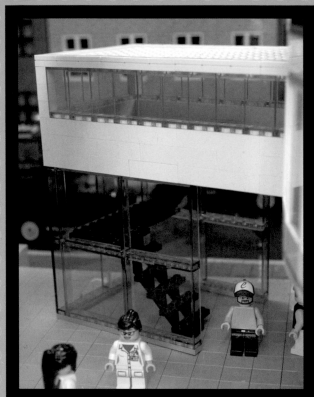

The stairway into the museum is surrounded by glass and looks very modern, just like the rest of the building.

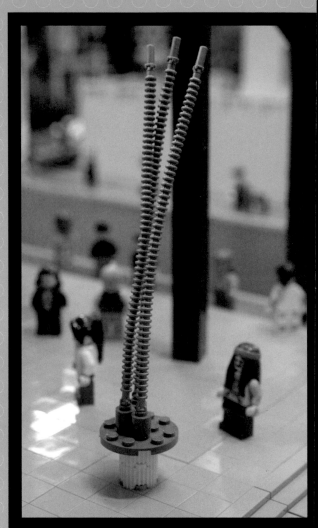

This sculpture outside the museum's entrance draws in visitors.

Art Museum Details

This curved walkway around the top of the museum has a unique tile floor.

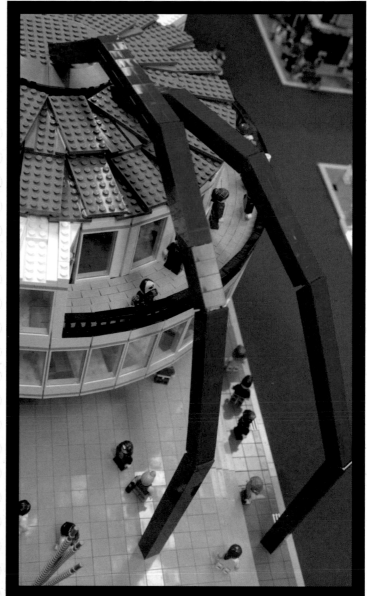

The biggest sculpture on display at the museum is part of the museum itself. The two red arms stretch from the ground to the top of the round roof.

4 Gallery

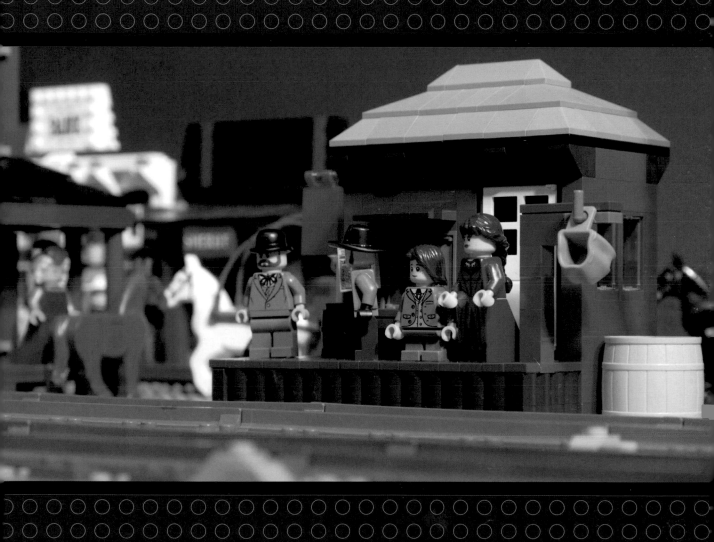

Shops and Diners

LET'S CHECK OUT EVEN MORE BUILDINGS.

IF YOU HAVEN'T YET CREATED AN ORIGINAL LEGO BUILD, WE ENCOURAGE YOU TO GIVE IT A TRY.

GET INSPIRED BY THE MODELS IN THIS CHAPTER!

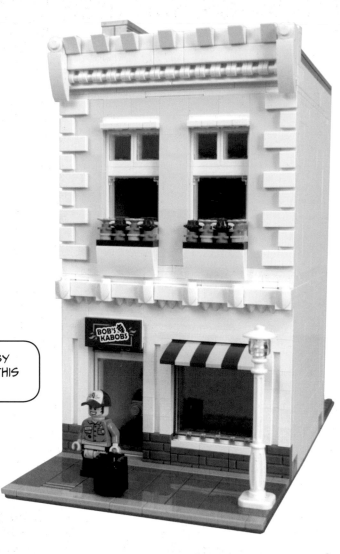

Good for Bob! He went from running a food truck to starting his own restaurant, Bob's Kabobs.

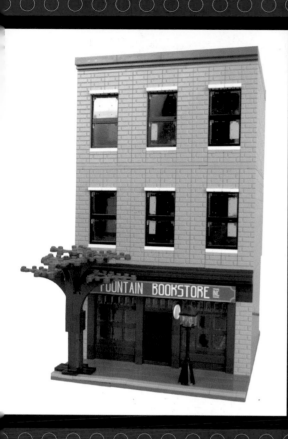

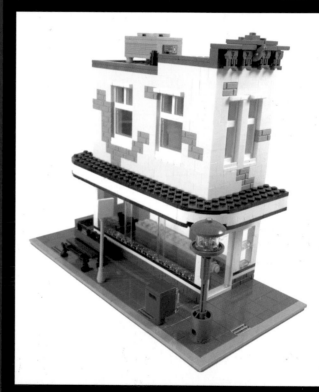

THIS MODEL IS A REPLICA OF FOUNTAIN BOOKSTORE, CREATED FOR OUR FIRST BOOK SIGNING.

This 9-stud-wide diner has a long counter and a large window to let in natural light.

City Houses

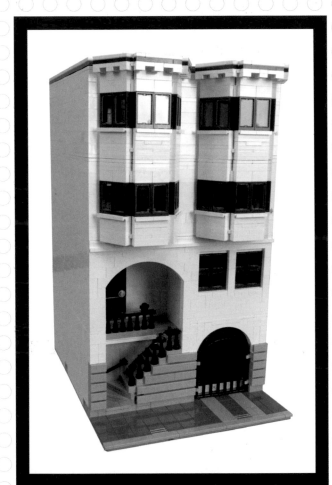

This San Francisco–style house has large bay windows, a staircase, and a gated garage.

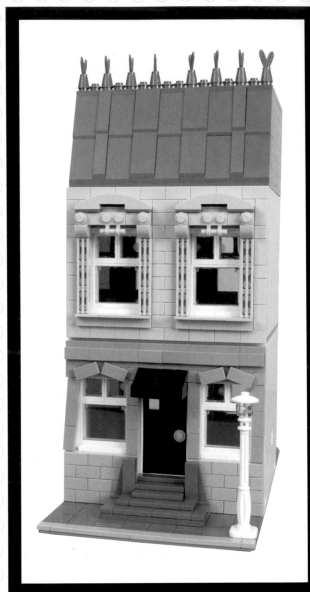

This house was built using the residential base from our first book, *The LEGO Neighborhood Book*.

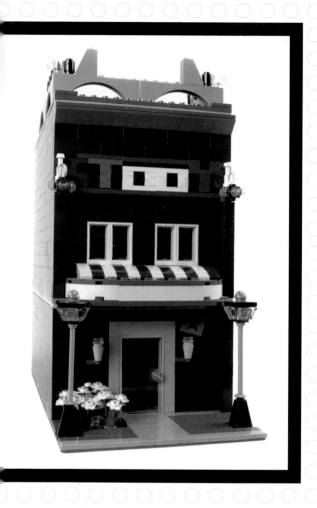

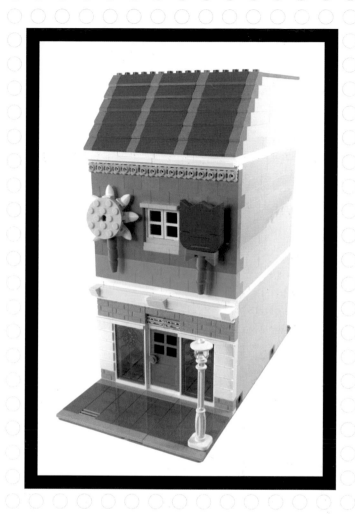

Whimsical Buildings

Think you just can't do it? You can! These modular
buildings were created by Jason's kids.

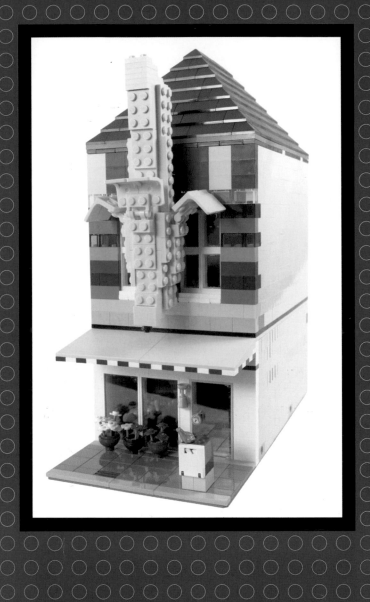

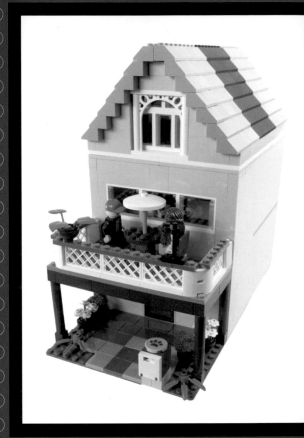

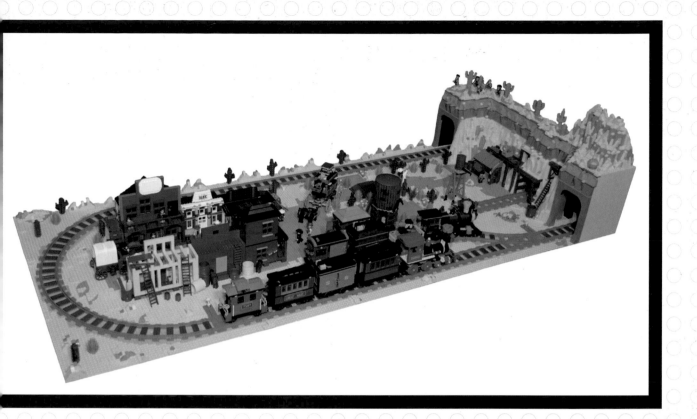

The Wild West

What other types of cities could you build using the techniques you've learned so far? Check out these examples of cities from different places and time periods. The first is a small town from the Old West.

Ancient Persia

Minarets and markets abound in this model of a city in ancient Persia.

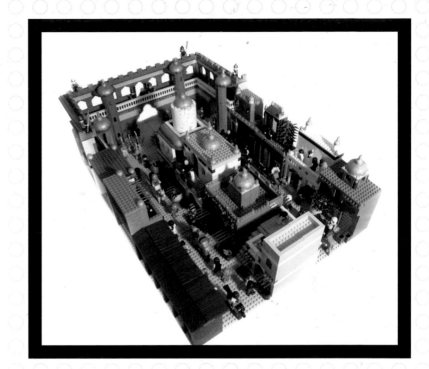

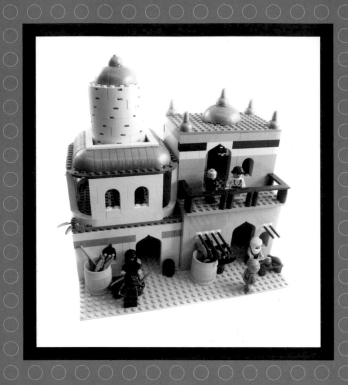

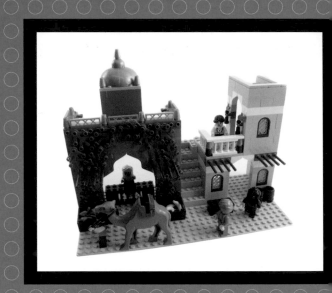

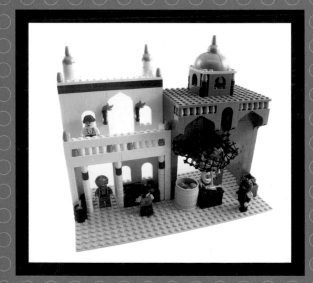

Pirate City

This Caribbean port city is packed with details from the
Golden Age of Piracy.

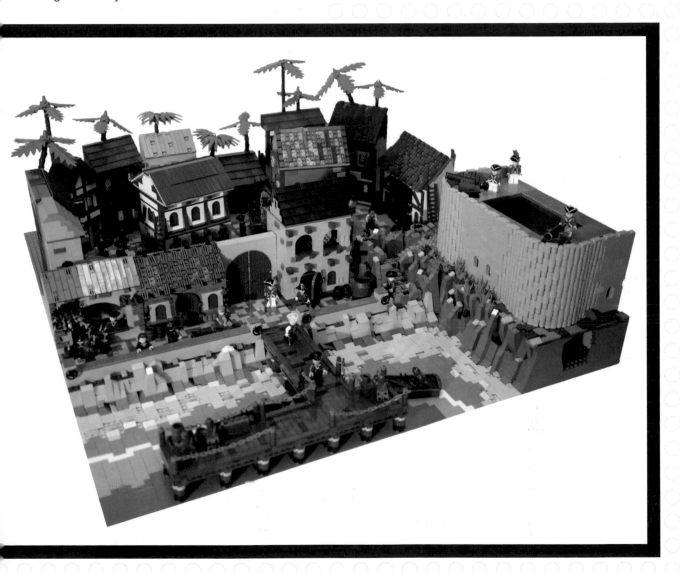

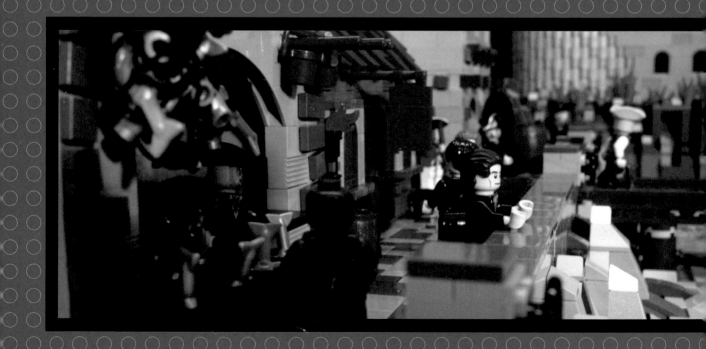

5 A Micro City

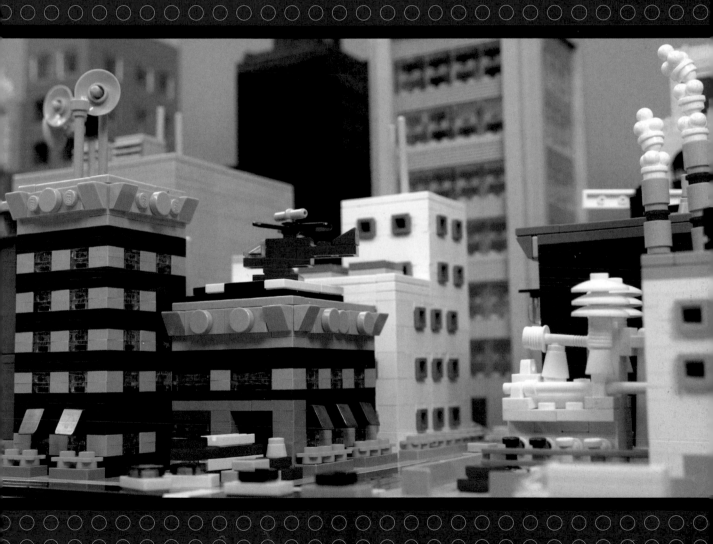

Building in Microscale

So far, we've shown you minifigure-scale models, which usually require thousands of pieces for each building. But this microscale model uses far fewer pieces to create a detailed city waterfront. Building in microscale is a good option if you have limited space or pieces to work with.

WANT TO BUILD A CITY BUT JUST DON'T HAVE ENOUGH PIECES?

TRY BUILDING ON A SMALLER SCALE.

If this model were minifigure scale, it would take up a whole room, but instead it fits on a table.

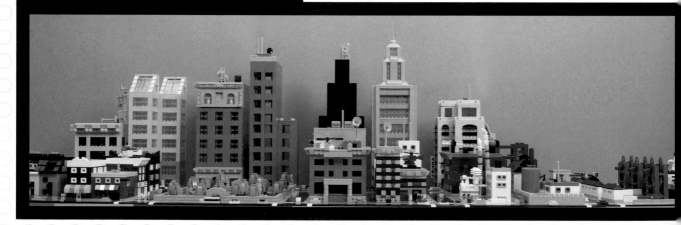

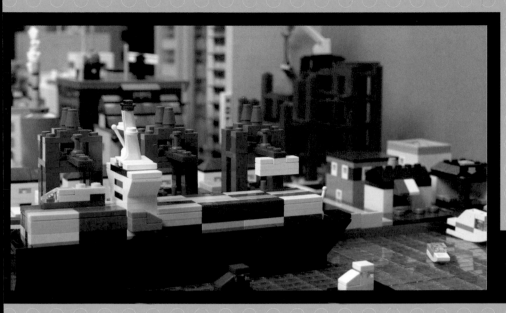

This port scene is made from basic bricks, tiles, and slopes.

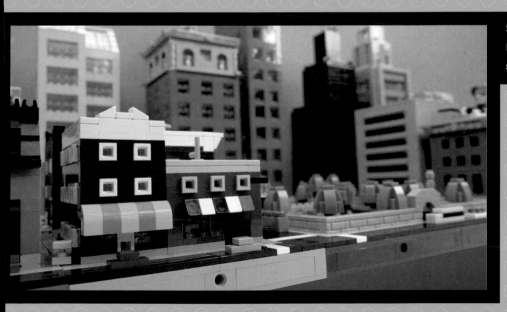

Skyscrapers can be built with ease on this scale.

Creating models on a smaller scale forces you to think about pieces differently. You must think about how you can create details with fewer pieces and still achieve the desired result.

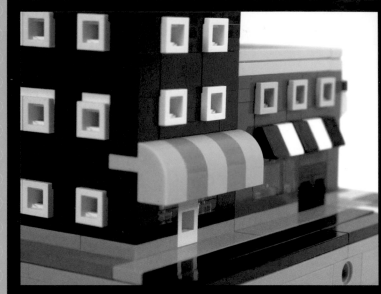

A headlight brick turned on its side with the bottom facing out becomes a window.

A jumper plate with a 1×1 tile on top becomes a car.

A small barrel becomes a rooftop water tower.

A Smaller Standard

Just as LEGO modular buildings have a "standard scale" of 32×32, microscale buildings also have an informal standard. Microscale is a quarter of that size: 16×16. Building at a consistent scale makes it easier for groups of people to combine their models into large city layouts at conventions, clubs, or meetings.

Take a look at how the base is built for one quarter of a city block. The most important details are the colors of the tiles that make up the street and sidewalk and the placement of the Technic bricks. Technic pins connect the bases together.

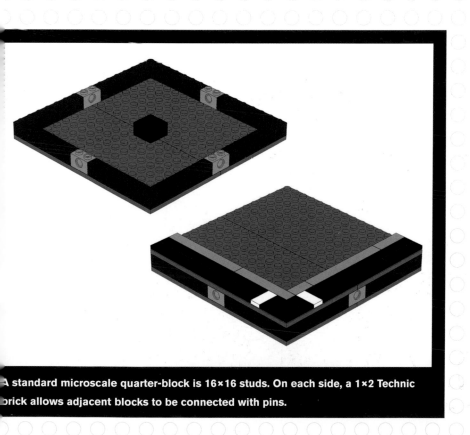

LET'S CHECK OUT SOME OF THE DETAILS OF THESE MICROSCALE BUILDS.

A standard microscale quarter-block is 16×16 studs. On each side, a 1×2 Technic brick allows adjacent blocks to be connected with pins.

Emergency Services

This well-equipped fire station has a helicopter and a ladder truck to put out fires. The green pieces are normally flowers, but here they are entire bushes.

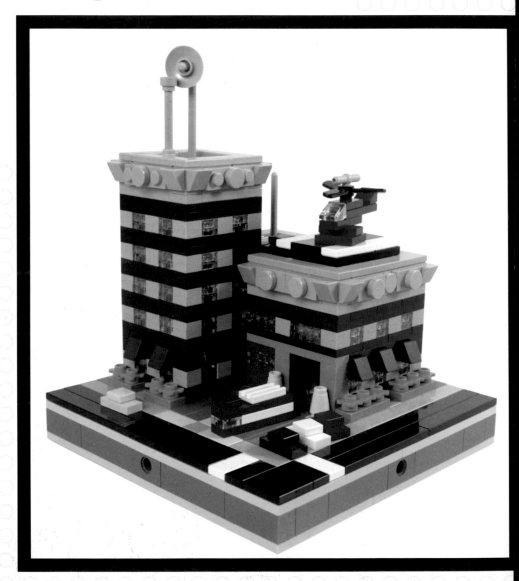

The hospital has a helicopter and a tiny ambulance for bringing in patients. A small pickup truck drives by on the street.

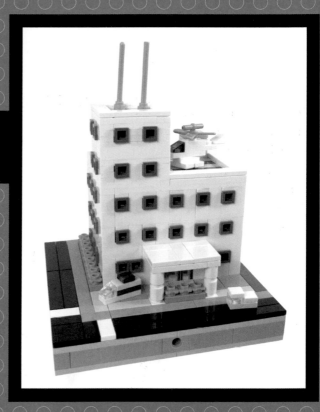

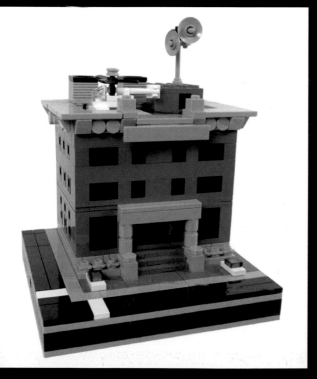

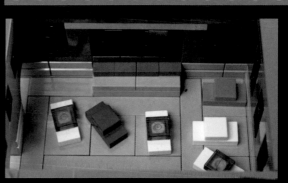

The police station has parking for squad cars by the front door, as well as a parking garage in the lower level with access in the alley.

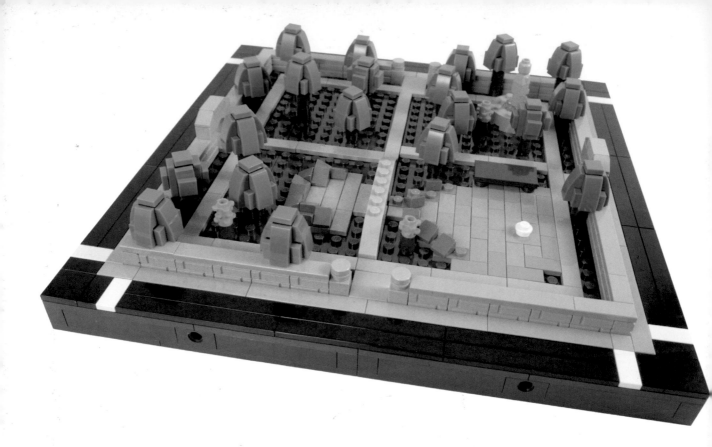

Park and School

These four sections connect to form a park.

A tiny archway marks the entrance, and a microfig statue looks over the trees.

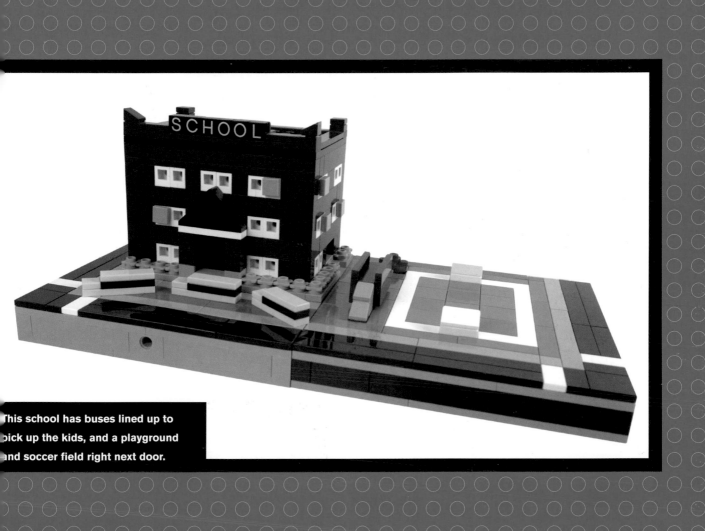

This school has buses lined up to
pick up the kids, and a playground
and soccer field right next door.

Neighborhood Buildings

These row houses feature bright colors and small front steps.

CHECK OUT THE TRASH CANS IN THE BACKYARDS.

These shops have awnings and trim on the windows and doors. The dark orange corner store even has an advertisement on its side.

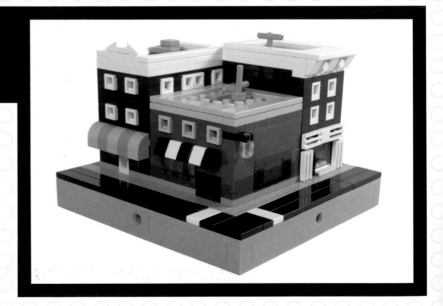

Office Buildings

This office building has some great details on the roof, such as AC units and communication equipment.

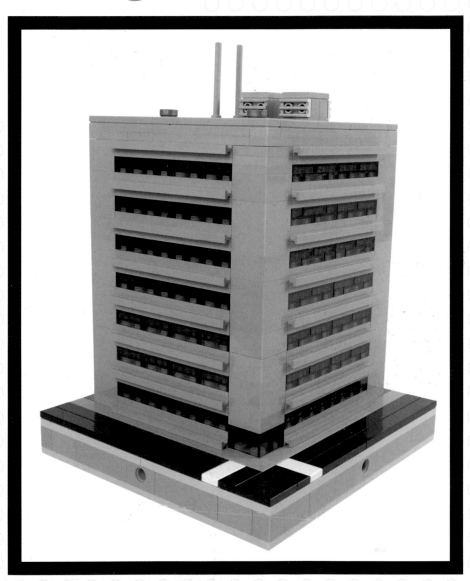

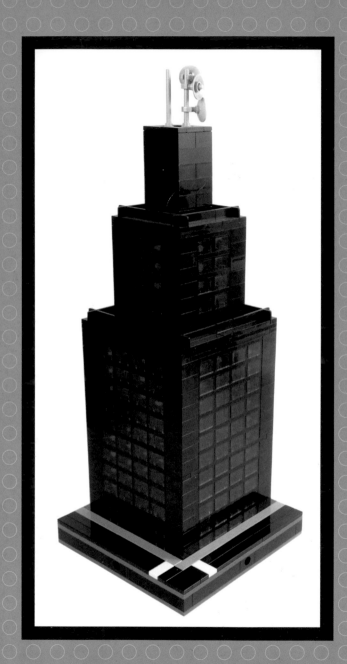

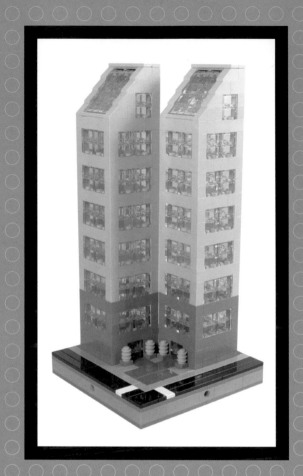

OFFICE BUILDINGS ARE EASY TO BUILD IF YOU HAVE ENOUGH PIECES TO MAKE THEM REGULAR AND SYMMETRICAL.

Factories

Sometimes I look at a piece and get inspired to create a building that uses it. That's what happened with this weathered Octan sign.

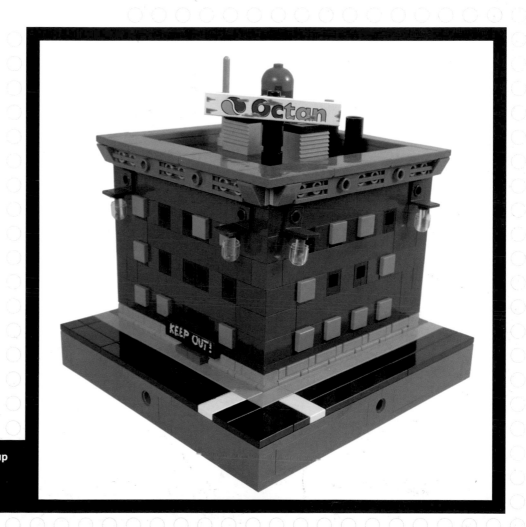

This old factory has boarded-up windows, signs, and even old-timey gaslights.

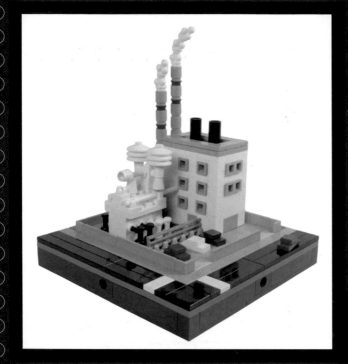

This power plant has a lot of fun details, such as the smoke, the metal fencing around the property, and the orange safety barricade.

This production facility has two big storage tanks and some red warning lights. Check out the roll-up garage door made of 1×2 textured bricks.

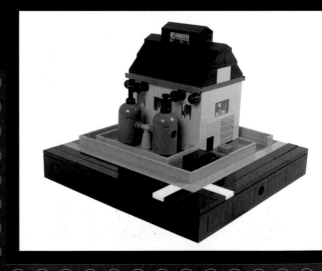

Commercial Buildings

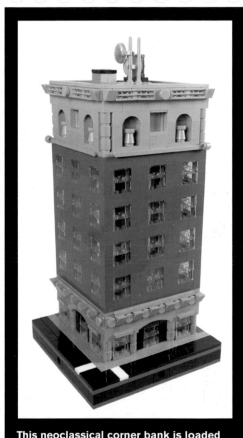

This neoclassical corner bank is loaded with facade details, even at this scale.

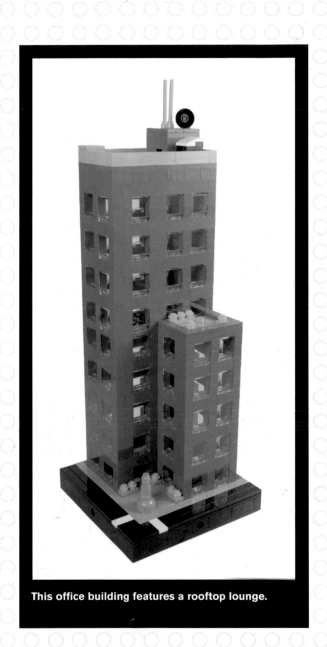

This office building features a rooftop lounge.

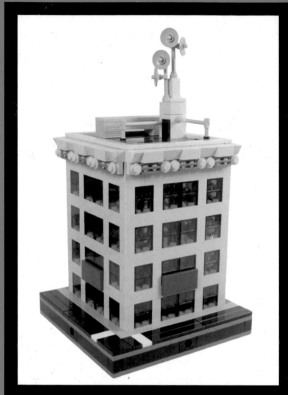

The roof of this newspaper publisher is loaded with communications equipment, as one would expect.

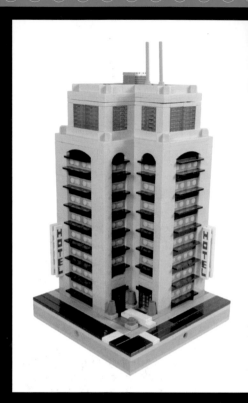

This deluxe hotel has a limo waiting by the door and a pool on the top level. The black 1×2 panels become balconies at this scale.

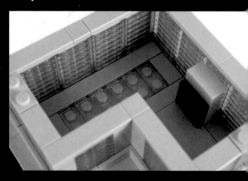

TRY USING TRANSPARENT COLOR BRICKS TO MAKE TINTED WINDOWS.

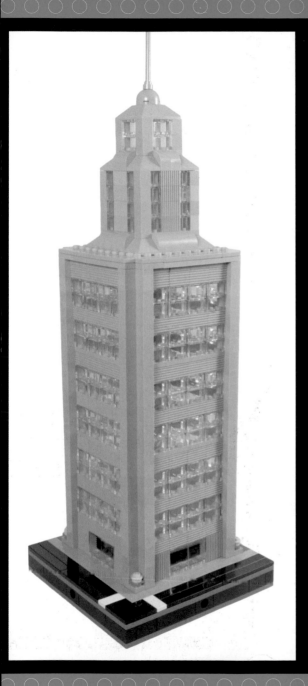

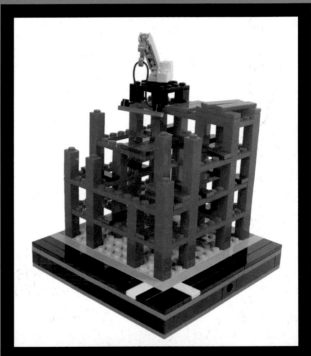

This building is under construction. It's currently just girders with wooden walkways for the builders to get around. The mini crane on top lifts pieces into place.

Skyscrapers like this one can be much bigger if you combine four 16×16 blocks and use the whole space to create a larger building.

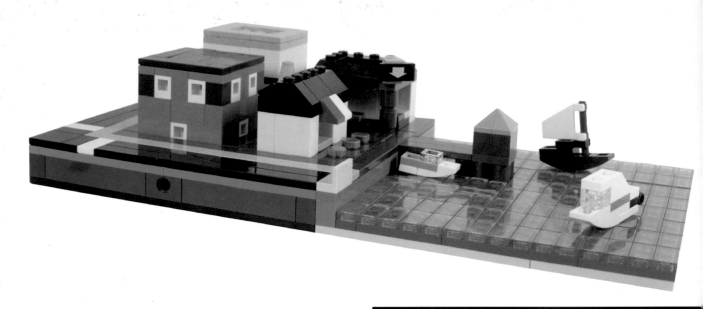

Harbor

Seaport shops line the bay, where tiny boats bring charm to the whole build.

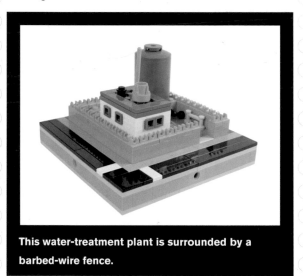

This water-treatment plant is surrounded by a barbed-wire fence.

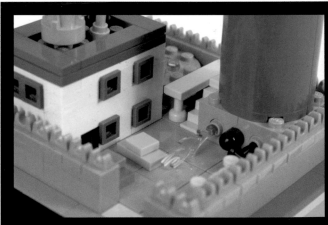

It looks like an accident has happened, with water going everywhere!

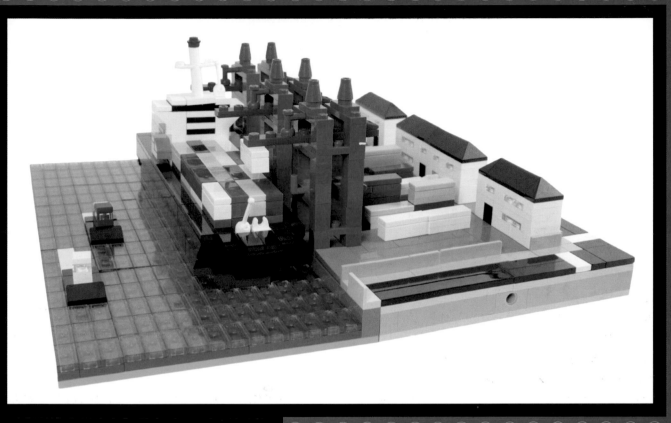

This seaport container yard and ship really bring this city to life. The port is complete with loading cranes and tugboats as well.

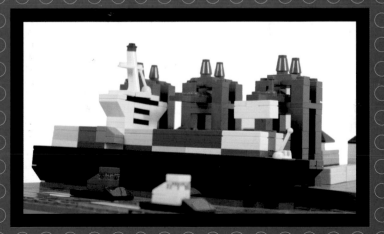

NOW THAT WE'VE TAKEN YOU AROUND THE CITY AND EVEN SHOWN YOU A SMALLER-SCALE CITY, IT'S TIME TO CHECK OUT ONE MORE BUILDING.

THIS BUILD IS PRETTY INTERESTING, SO WE'VE PROVIDED INSTRUCTIONS SO YOU CAN BUILD IT TOO.

Corner Condominiums

These corner condominiums have a European style that would look great in any city layout. The gated courtyard in front provides a shared front yard for the residents. Both buildings feature full interiors, including kitchens, living areas, a bedroom, and even a LEGO toy building room. Let's get started!

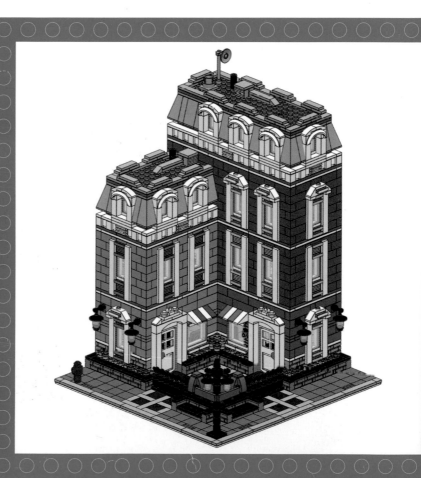

Bill of Materials

If you need to order pieces, check out *https://www.bricklink.com/* or *https://www.lego.com/*. For a parts list you can download, visit *https://nostarch.com/legoneighborhood2/*. Don't forget you can always substitute or swap colors.

Want more models? To find other building instructions like this, visit *https://brickcitydepot.com/*.

WHOA, THAT'S A LOT OF PIECES!

1x

1x

2x 4x 2x 4x 2x 1x 9x 2x 2x 2x 1x 1x 2x 1x 1x 1x

7x 3x 4x 4x 2x 4x 1x 2x 3x 31x 6x 22x 2x 12x 16x 2x 2x 1x 7x 11x 5x 2x 1x 4x 6x

2x 45x 28x 16x 1x 2x 1x 1x 2x 13x 4x 29x 2x 4x 14x 1x 60x 19x

1x 2x 6x 6x 6x 4x 2x 9x 1x

1x 2x 2x 1x 1x 1x 3x 1x 20x 2x 2x 21x 2x 3x 1x 1x 1x

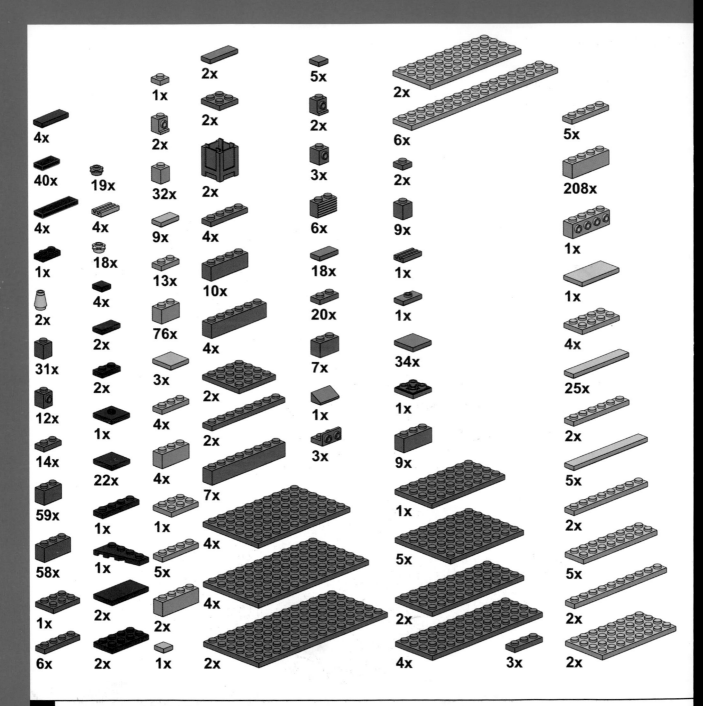

4x
40x
4x
1x
2x
31x
12x
14x
59x
58x
1x
6x

19x
18x
4x
2x
2x
1x
22x
1x
1x
2x
2x

1x
2x
32x
9x
13x
76x
3x
4x
4x
1x
5x
2x
1x

2x
2x
2x
4x
10x
4x
2x
2x
7x

5x
2x
3x
6x
18x
20x
7x
1x
3x

2x
6x
2x
9x
1x
1x
34x
1x
9x
1x
5x
2x
4x

2x

5x
208x
1x
1x
4x
25x
2x
5x
2x
5x
2x

3x

2x

First Floor

1

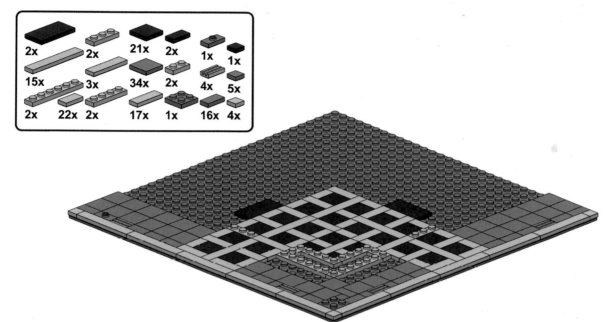

2x 2x 21x 2x 1x 1x
15x 3x 34x 2x 4x 5x
2x 22x 2x 17x 1x 16x 4x

2

3x 2x 1x 11x 1x 9x 1x 6x 5x 1x
2x 1x 2x 12x 11x 1x 7x 1x 2x 1x 1x

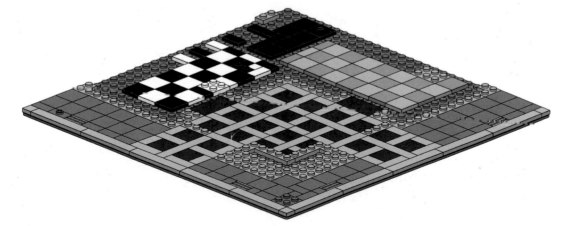

3

1x 4x 5x
6x 4x 1x 1x

4

3x 1x
2x 1x
8x 5x

5

4x 7x
2x 2x

6

2x 1x 1x 2x
2x 8x 3x 22x 5x 12x

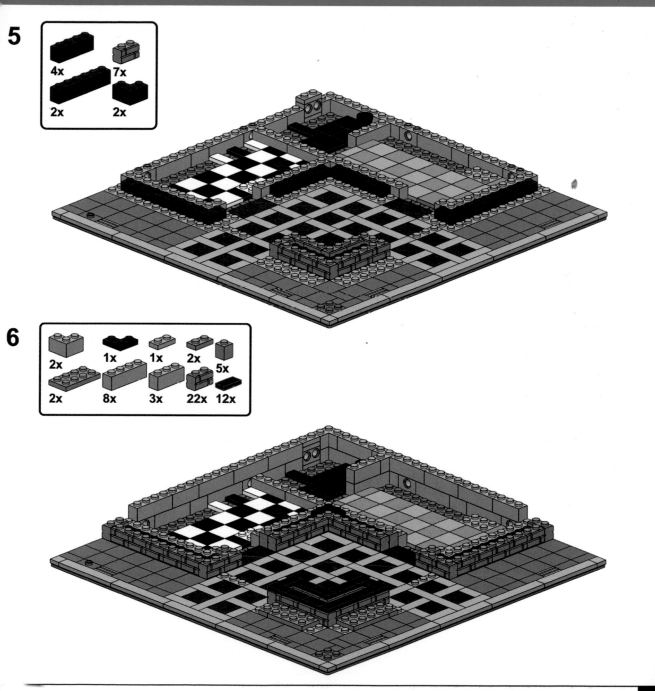

7

1x 1x 1x 18x 2x

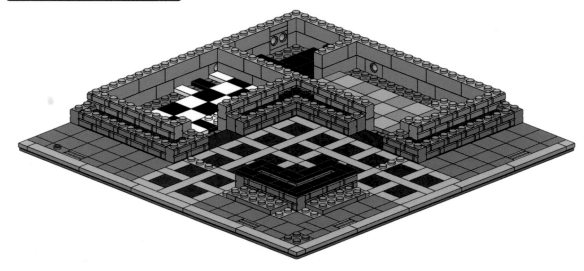

8

1x 32x

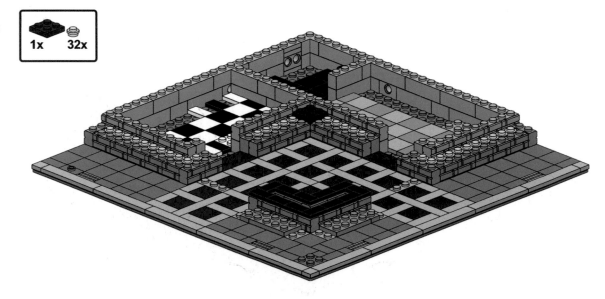

9

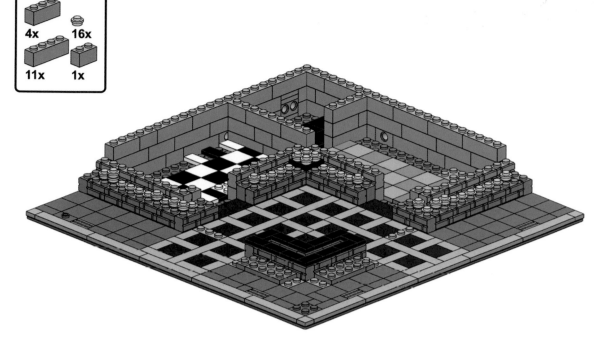

10

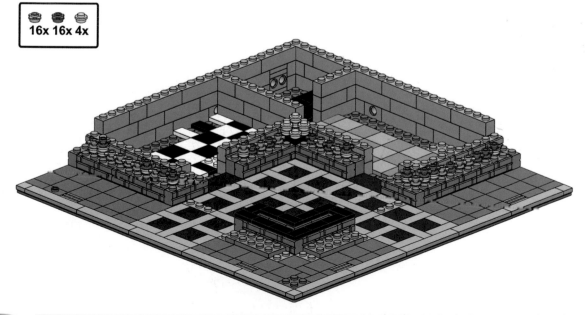

11

1x 4x 2x
4x 1x 12x

12

4x 1x 1x 2x 2x
2x 3x 5x 2x
9x 4x 2x 1x 28x 1x

13

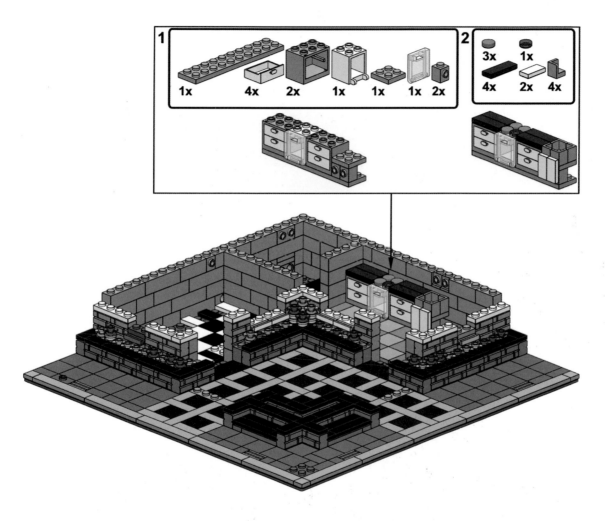

14

1x 1x 1x
7x 5x 2x 1x
1x 2x 4x 6x

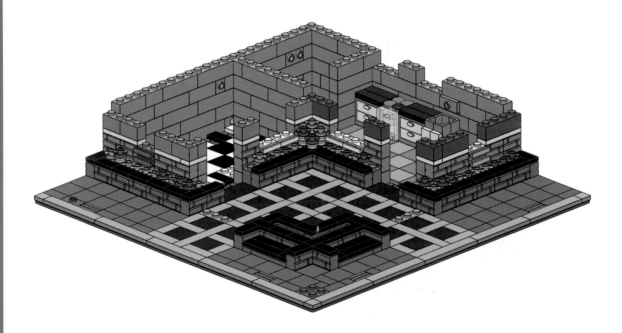

15

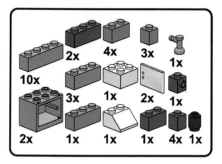

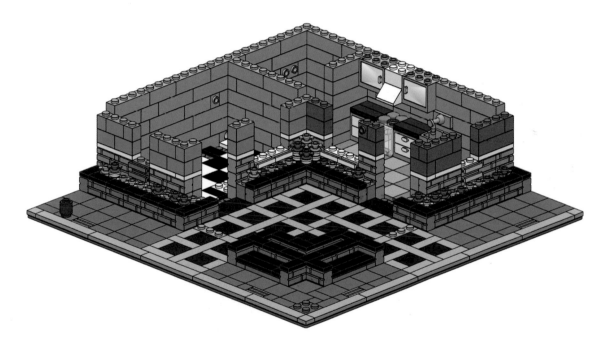

16

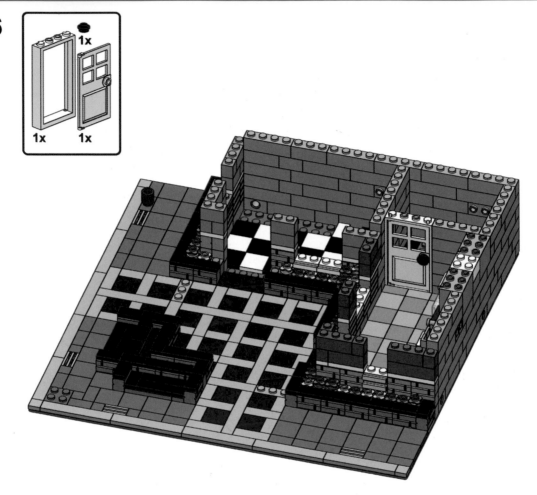

17

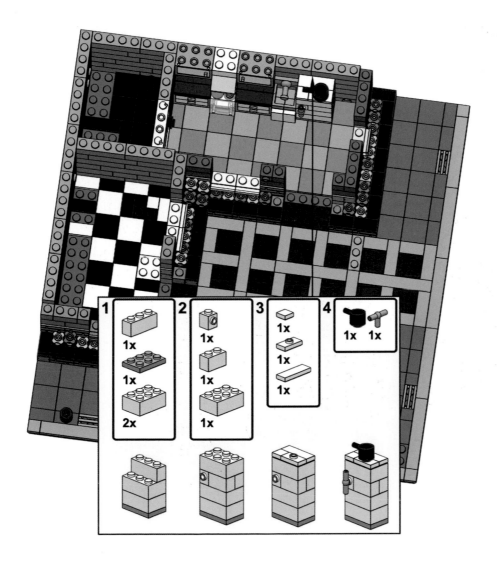

18

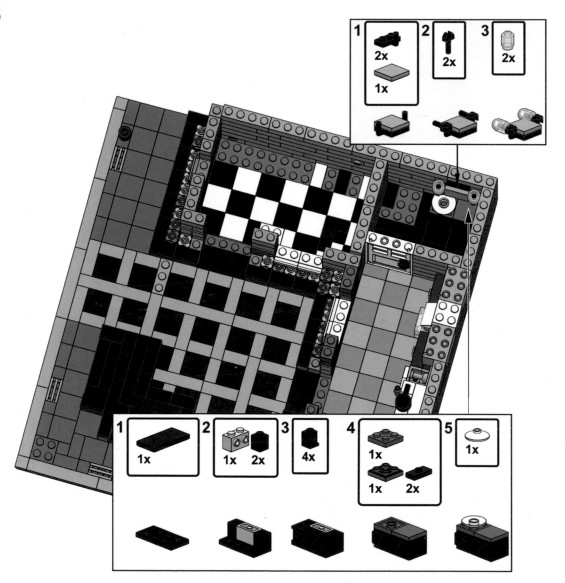

19

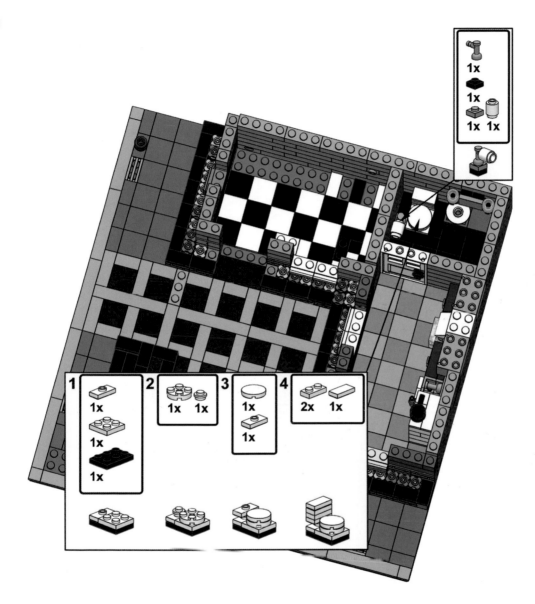

20

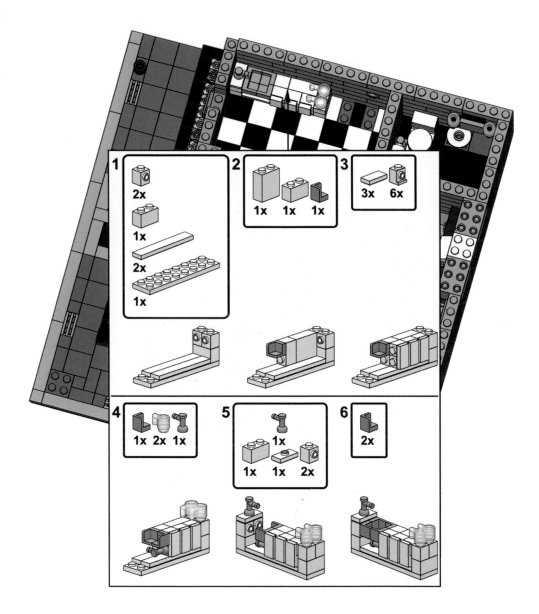

21

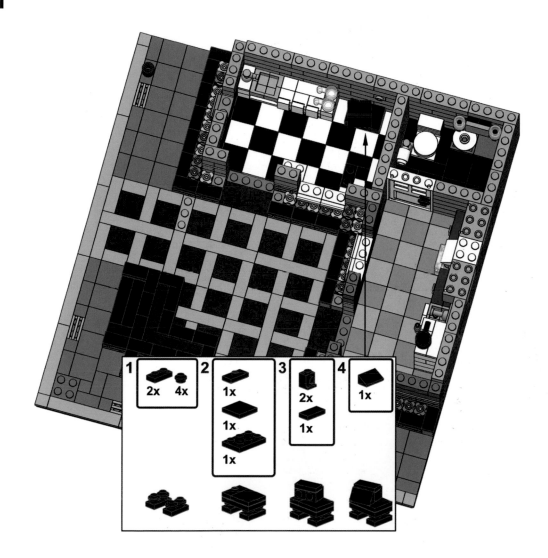

22

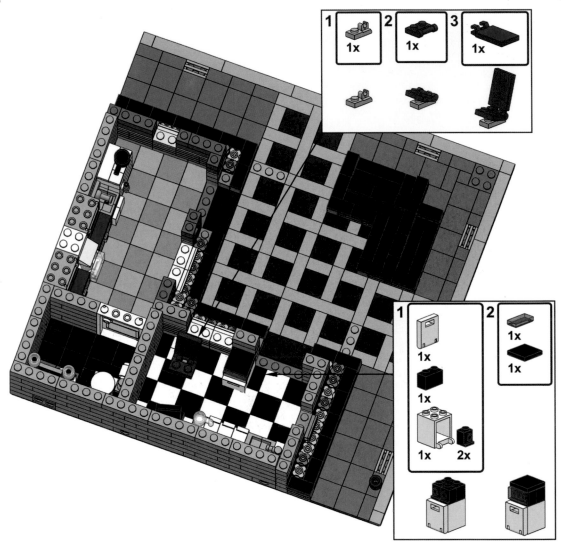

23

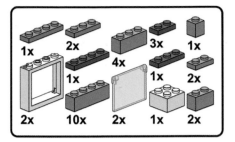

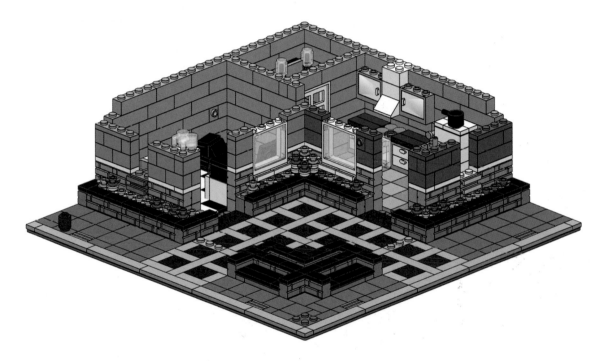

24

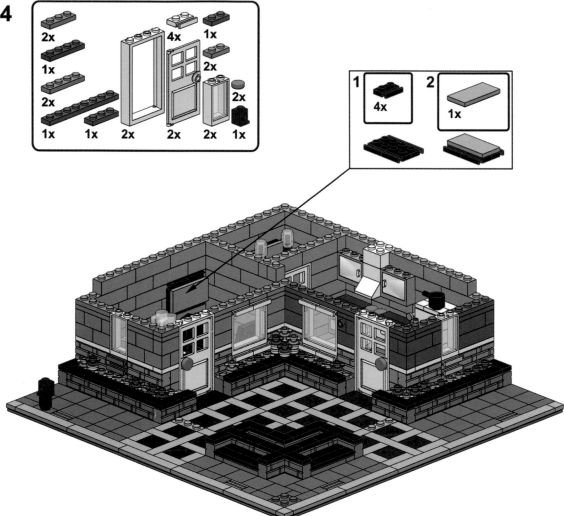

25

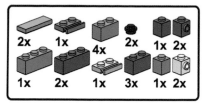

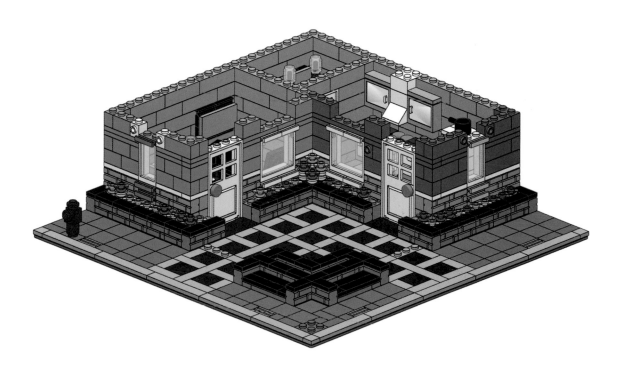

26

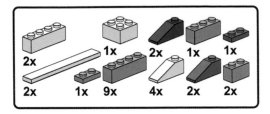

2x 2x 1x 1x 9x 2x 1x 4x 1x 2x 2x

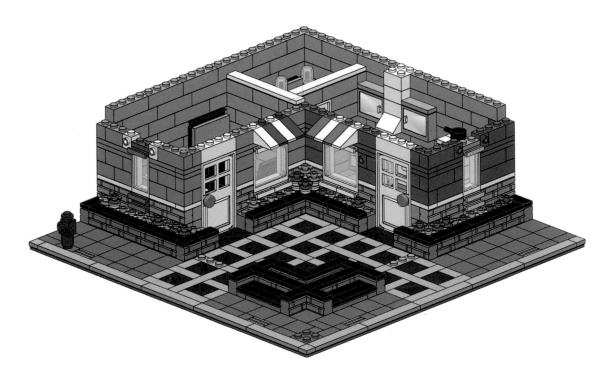

27

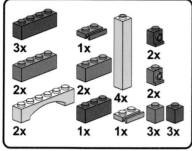

3x
2x
2x
1x
2x
1x
4x
1x
2x
2x
3x 3x

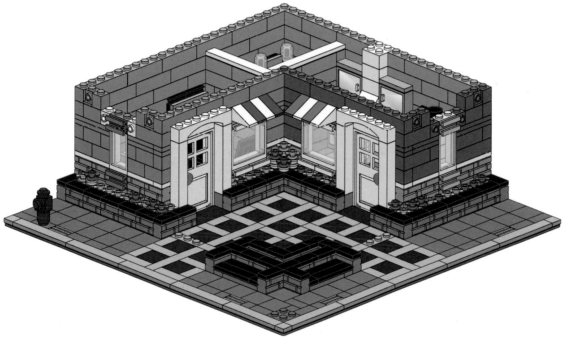

28

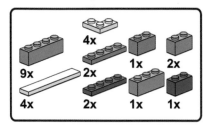

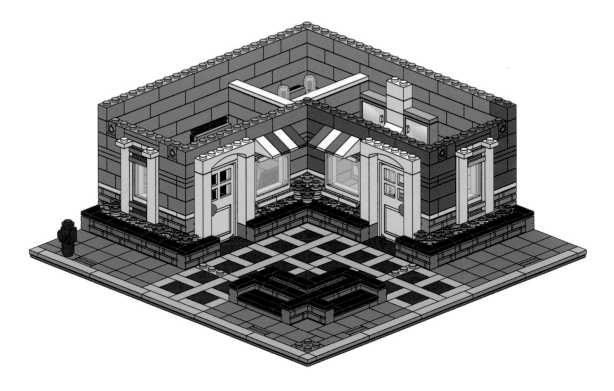

29

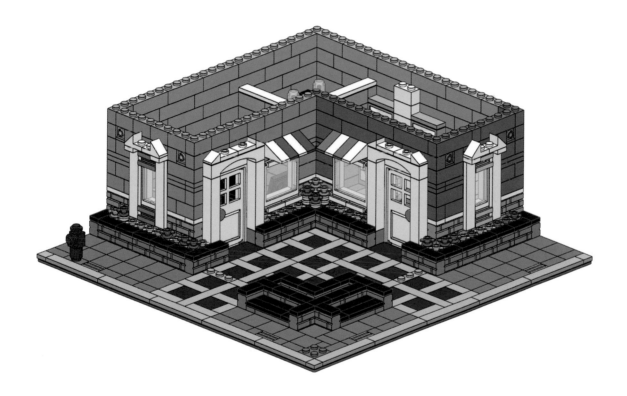

30

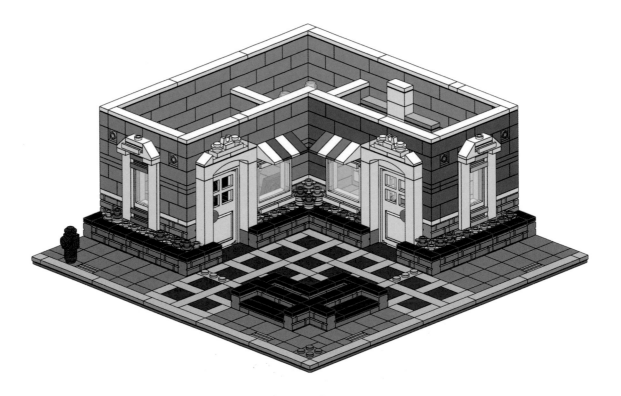

31

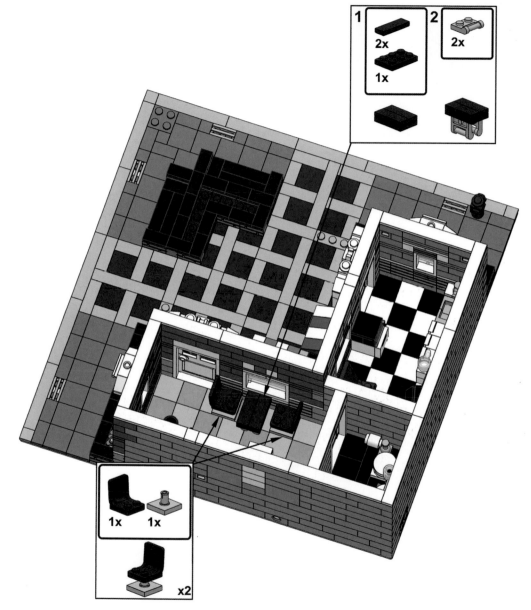

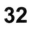**32**

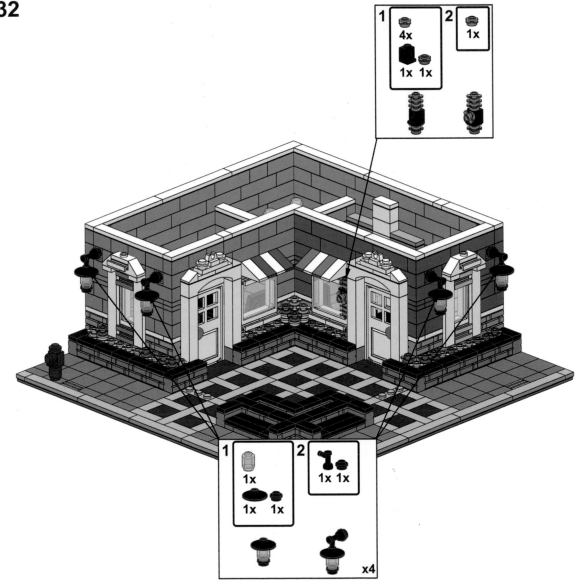

33

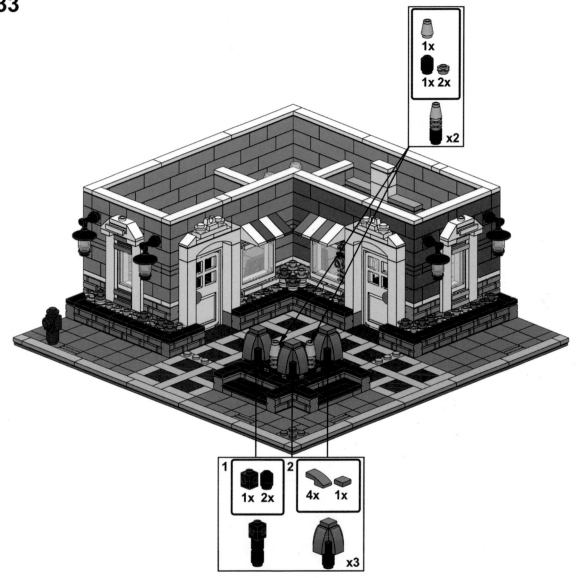

1x

1x 2x

x2

1
1x 2x

2
4x 1x

x3

34

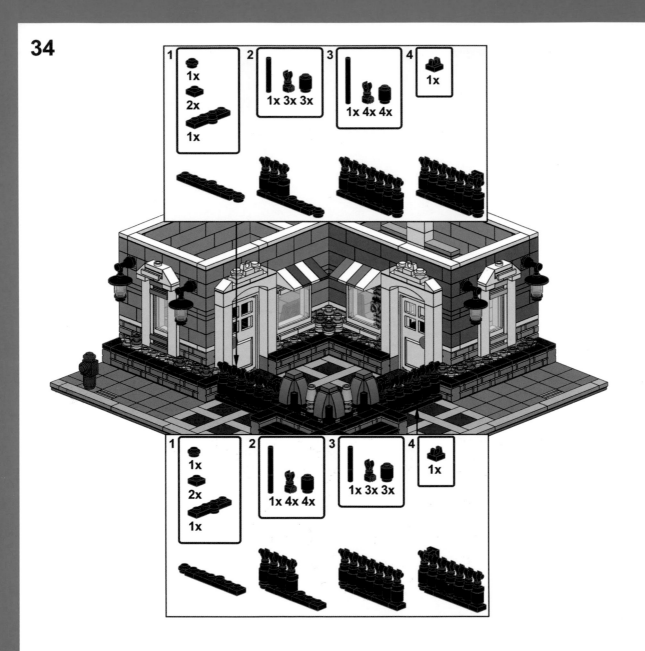

35

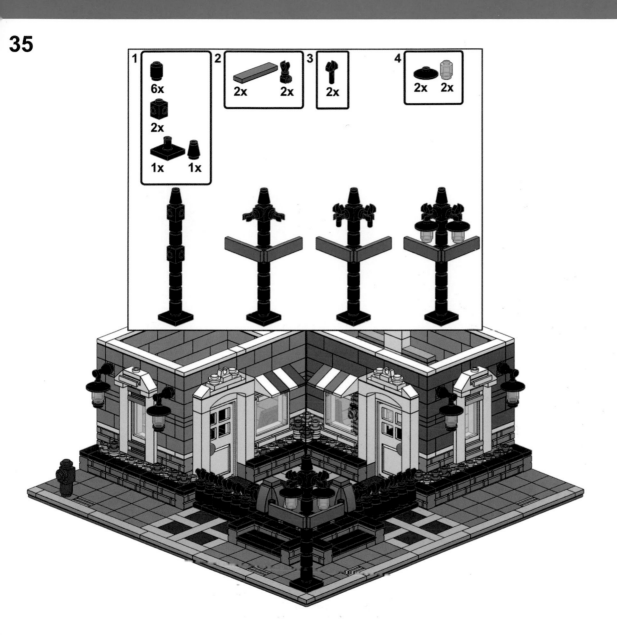

Second Floor

1

1x
1x
2x
2x
1x

2

1x
1x
1x 3x

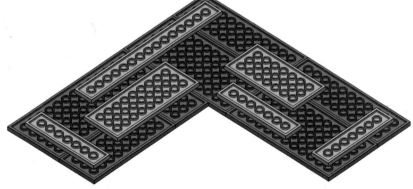

3

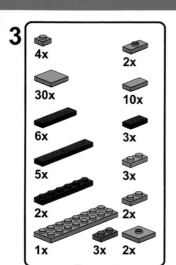

4x
2x
30x
10x
6x
3x
5x
3x
3x
2x
2x
1x
3x
2x

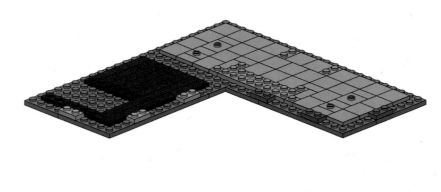

4

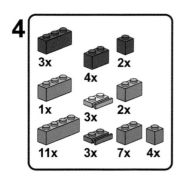

3x
2x
4x
1x
3x
2x
11x
3x
7x
4x

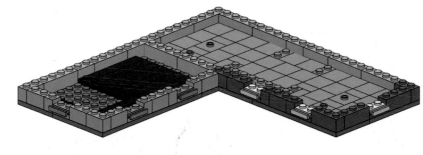

5

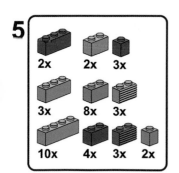

2x
2x
3x
3x
8x
3x
10x
4x
3x
2x

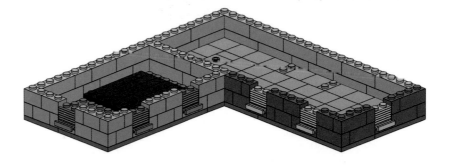

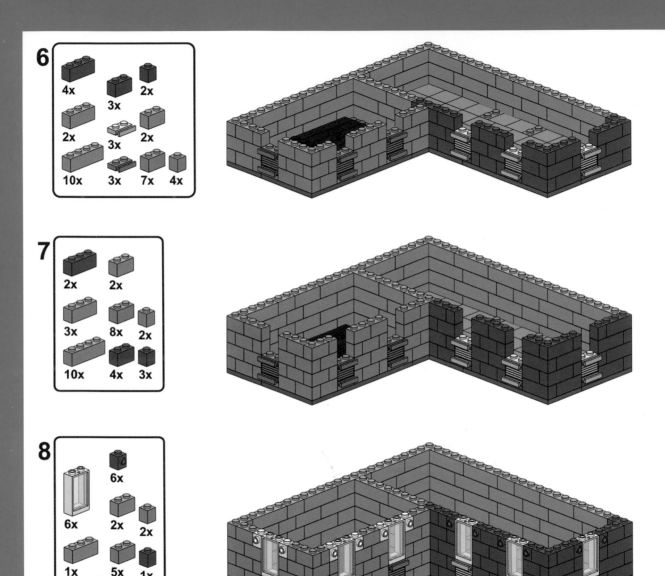

9

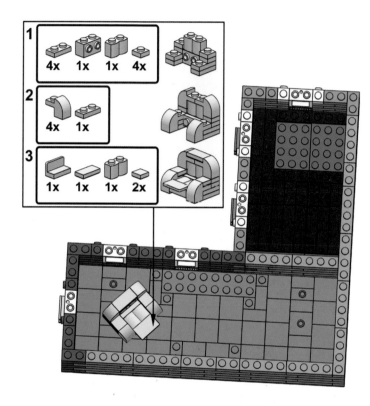

1　4x　1x　1x　4x

2　4x　1x

3　1x　1x　1x　2x

10

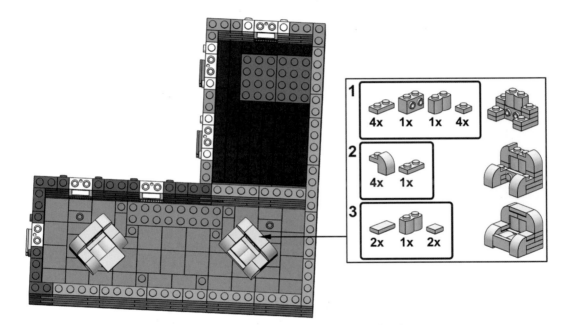

11

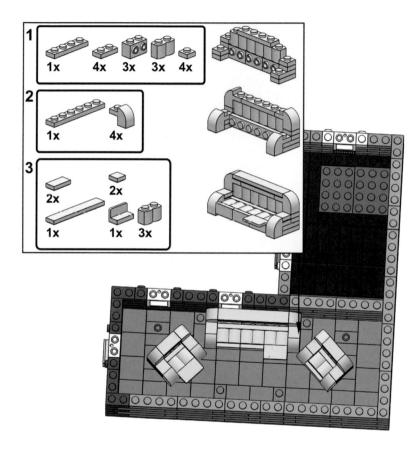

1
1x 4x 3x 3x 4x

2
1x 4x

3
2x 2x
1x 1x 3x

12

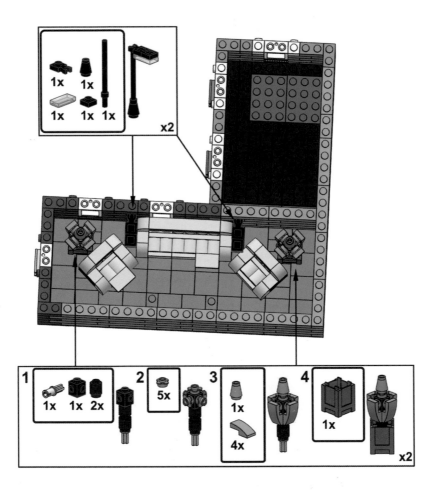

13

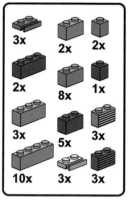

3x 2x 2x
2x 8x 1x
3x 5x 3x
10x 3x 3x

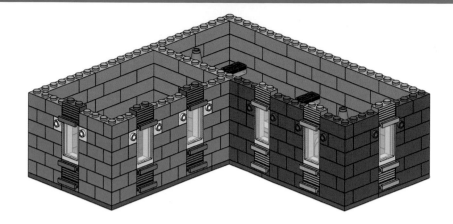

14

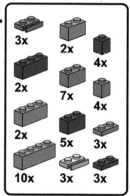

3x 2x 4x
2x 7x 4x
2x 5x 3x
10x 3x 3x

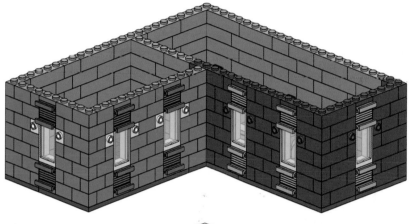

15

2x
23x

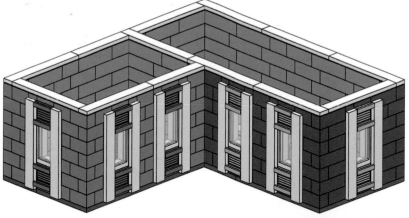

16

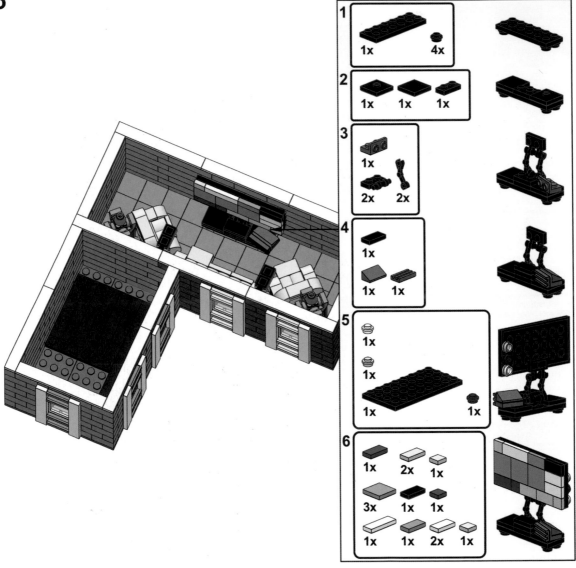

1
1x 1x
1x
1x 1x

2
3x 1x 3x

3
4x 3x 1x

4
1x 1x

5
1x
1x
1x 1x 1x

6
1x
4x

7
2x 1x
1x 1x

8
1x
4x

9
2x
1x
1x

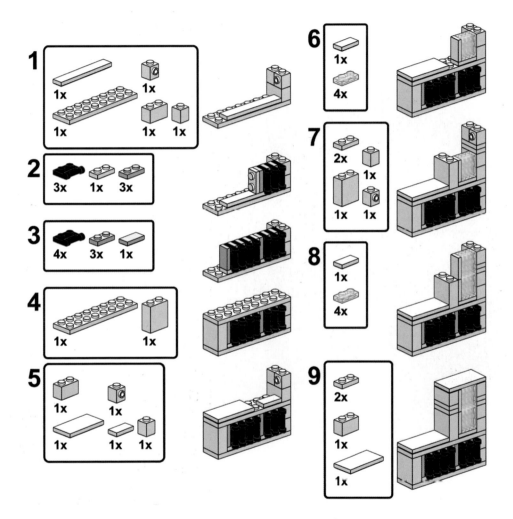

17

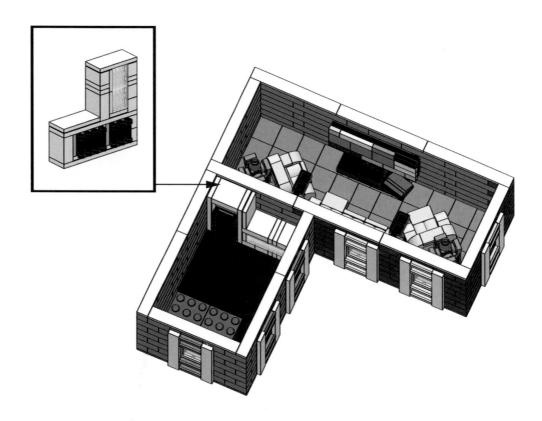

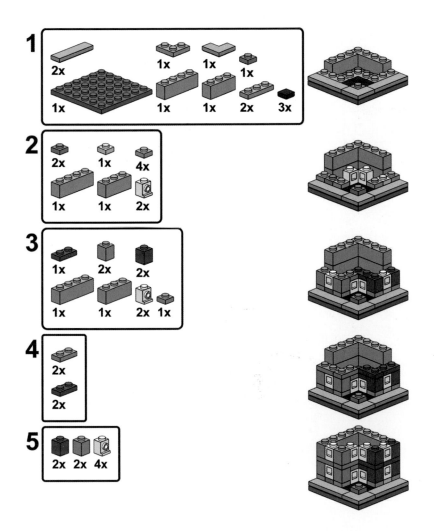

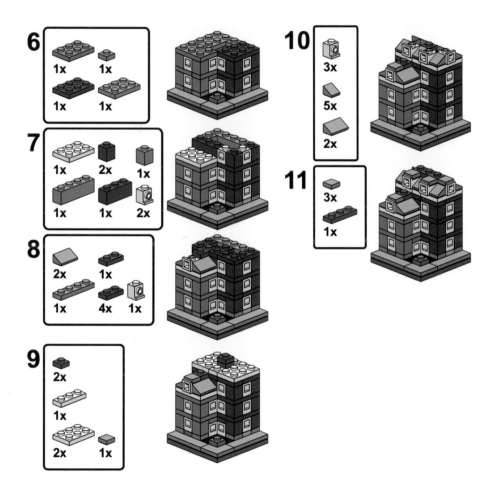

6
1x 1x
1x 1x

7
1x 2x 1x
1x 1x 2x

8
2x 1x
1x 4x 1x

9
2x
1x
2x 1x

10
3x
5x
2x

11
3x
1x

18

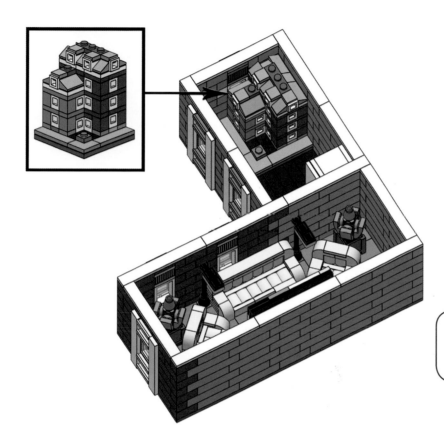

WHOA! CHECK OUT THE MICRO BUILDING OF THIS BUILDING!

Third Floor

1

1x
1x
2x
2x
1x

2

1x
1x
1x
1x
2x

3

1x
17x
8x
2x
2x

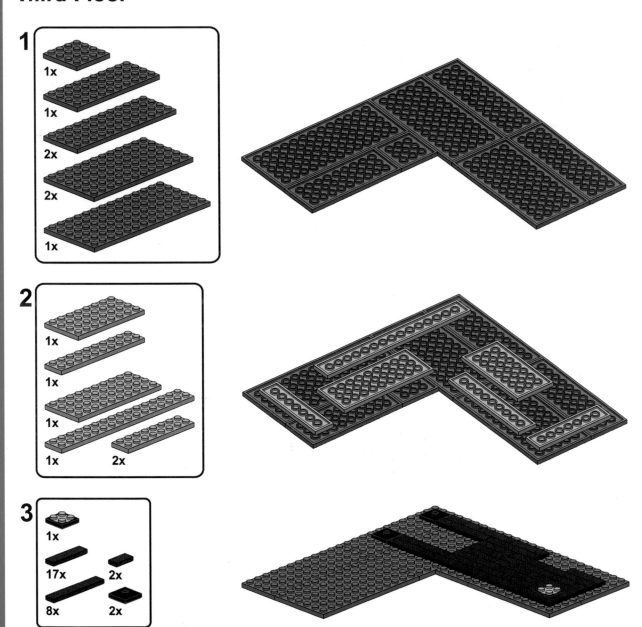

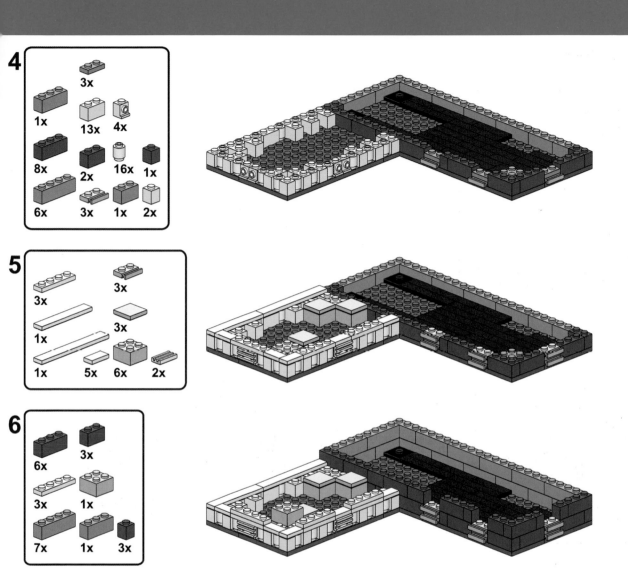

4

3x
1x
13x
4x
8x
2x
16x
1x
6x
3x
1x
2x

5

3x
3x
1x
3x
1x
5x
6x
2x

6

6x
3x
3x
1x
7x
1x
3x

7

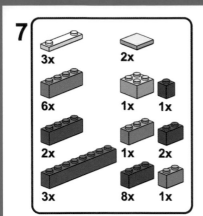

3x
2x
6x
1x 1x
2x
1x 2x
3x
8x 1x

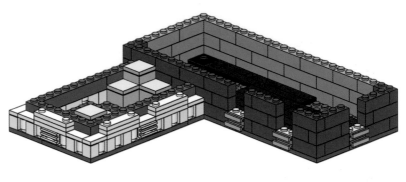

8

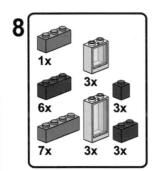

1x
3x
6x
3x
7x 3x 3x

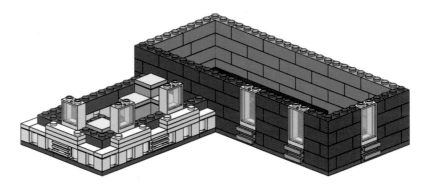

9

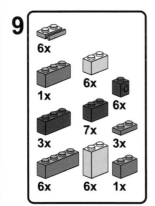

6x
1x
6x
6x
3x
7x 3x
6x 6x 1x

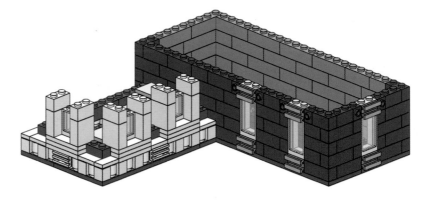

10

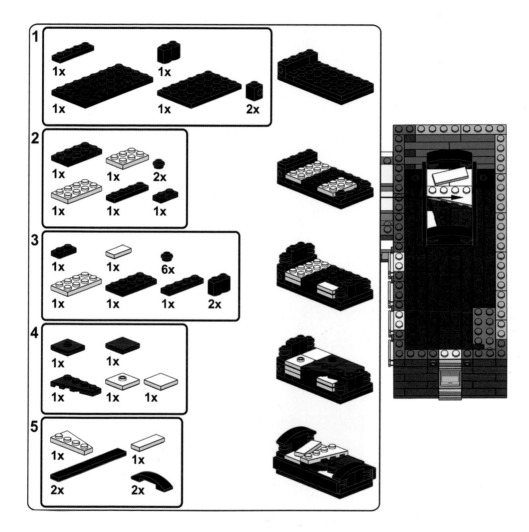

11

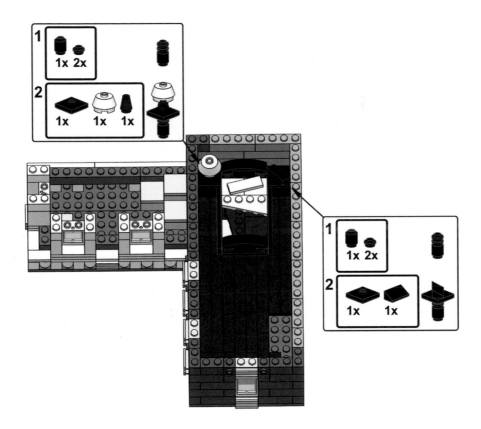

12

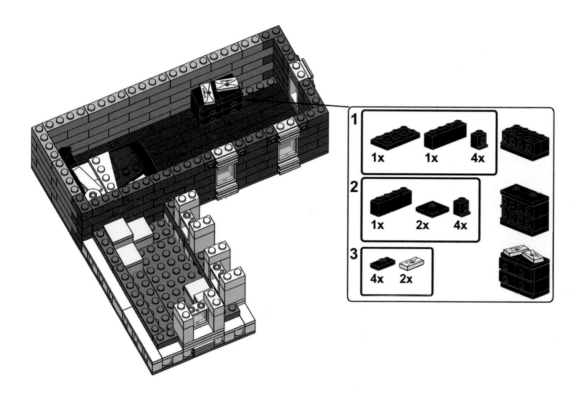

13

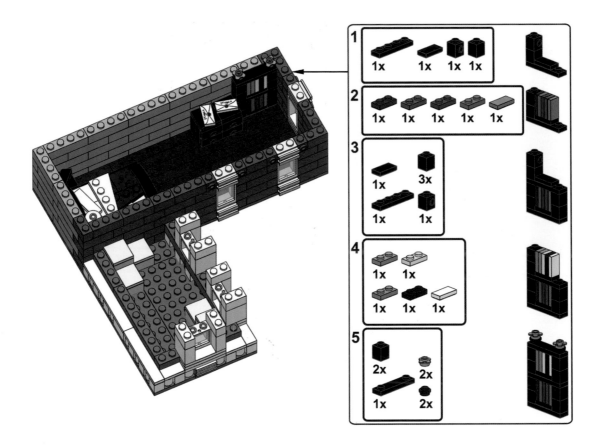

14

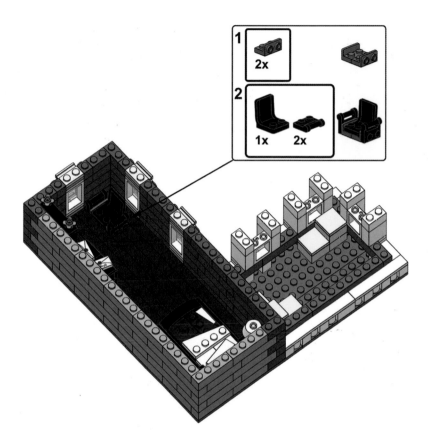

15

2x

6x 6x

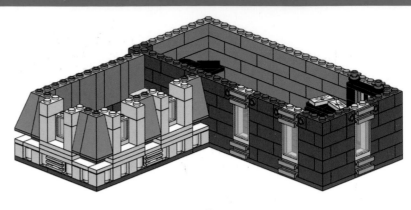

16

6x

3x

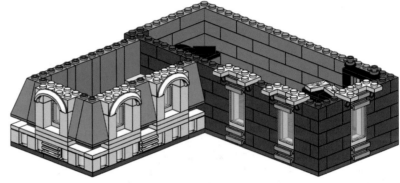

17

6x 4x

1x 4x

4x 1x

1x 3x 6x 1x

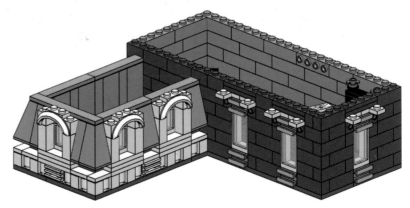

18

7x

1x

7x 6x

6x 1x

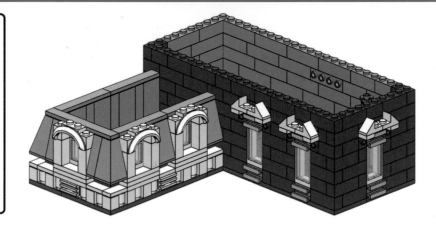

19

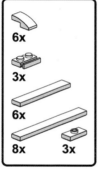
6x

3x

6x

8x 3x

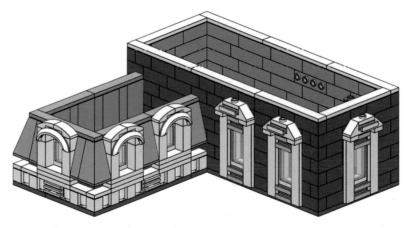

20

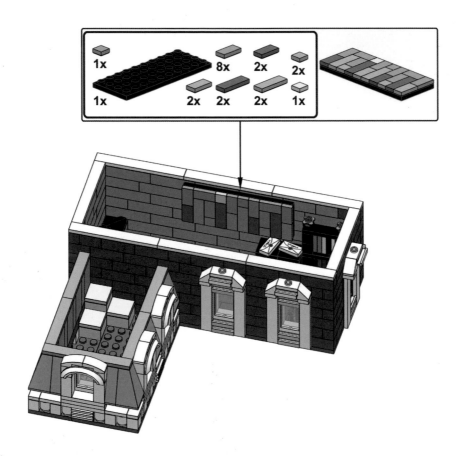

1x
1x
8x
2x
2x
2x
2x
2x
2x
1x

Attic

1

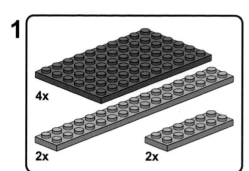

4x

2x

2x

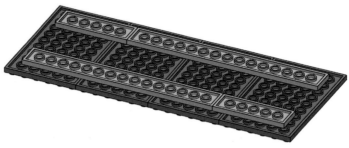

2

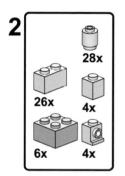

28x

26x

4x

6x

4x

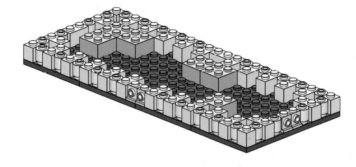

3

4x

1x

4x

4x

5x

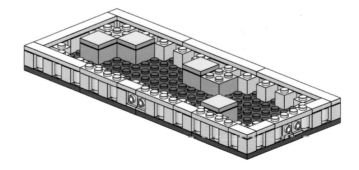

4

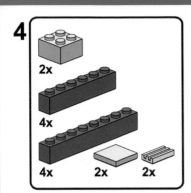

2x

4x

4x 2x 2x

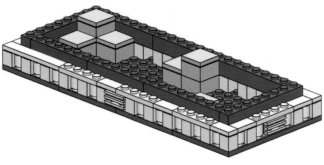

5

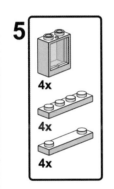

4x

4x

4x

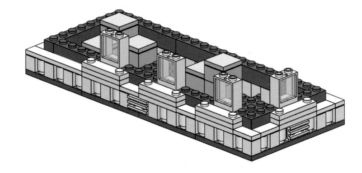

6

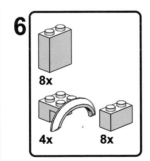

8x

4x 8x

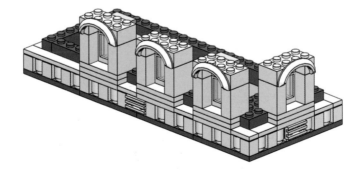

7

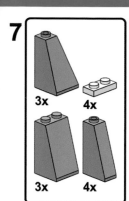

3x 4x

3x 4x

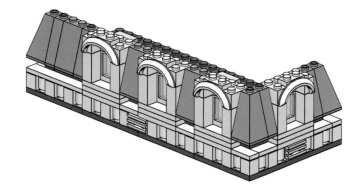

8

1x

9x 8x

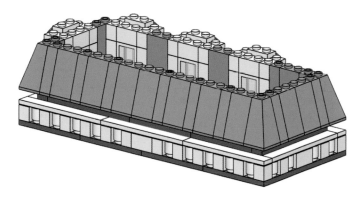

9

4x

4x

4x

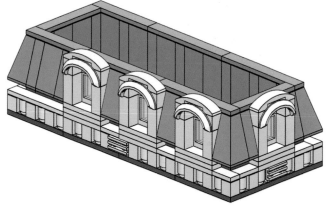

Orange Roof

1

1x
3x

2

2x
2x

3

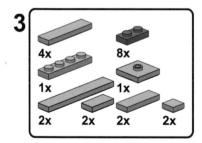

4x
8x
1x
1x
2x
2x
2x
2x

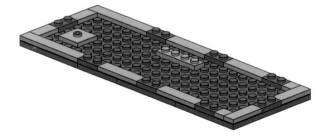

4

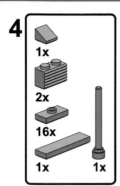

1x
2x
16x
1x 1x

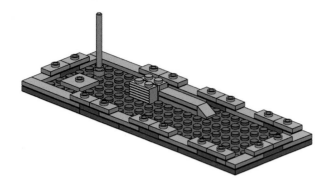

5

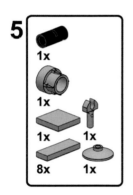

1x
1x
1x 1x
8x 1x

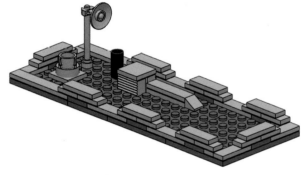

Blue Roof

1
1x
2x
2x

2
4x
2x
2x
1x
1x
5x

3
1x
10x
1x

4
2x
1x
5x

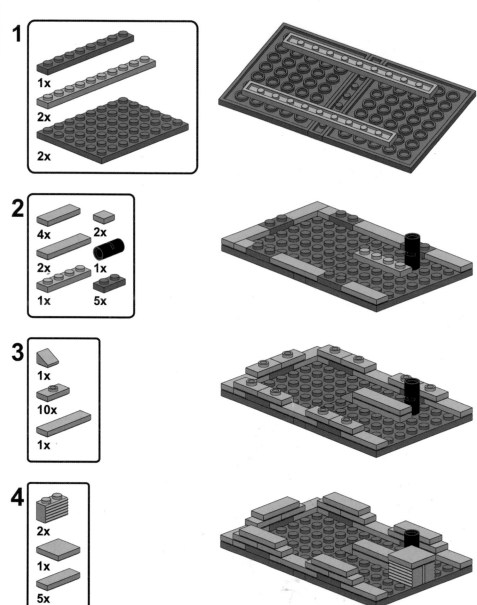

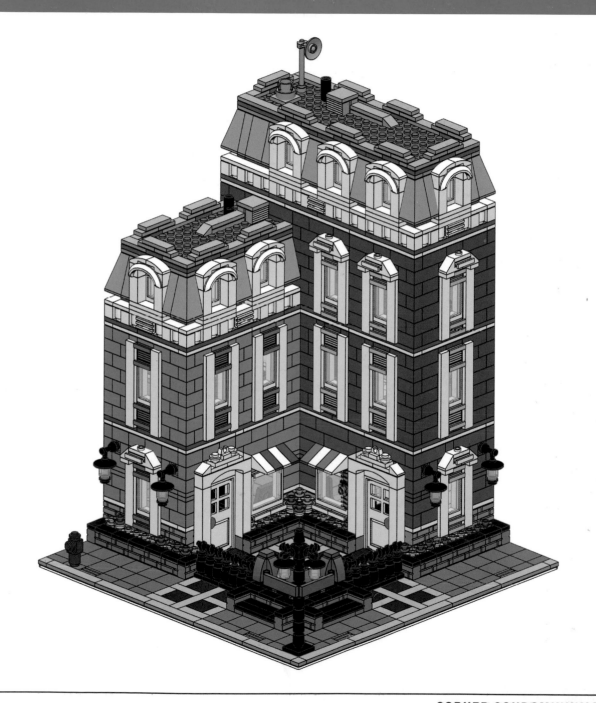

WE HOPE THAT OUR TOUR THROUGH THE CITY AND THE BUILDING INSTRUCTIONS HAVE INSPIRED YOU TO MAKE A MODULAR BUILDING OF YOUR OWN—OR A MICROSCALE BUILDING!

FOR MORE INSPIRATION, PICK UP *THE LEGO NEIGHBORHOOD BOOK.*

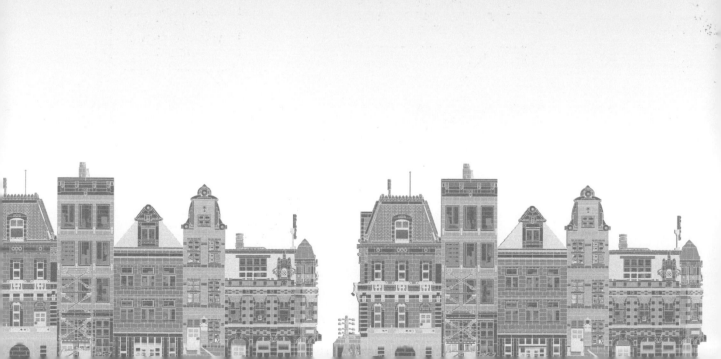

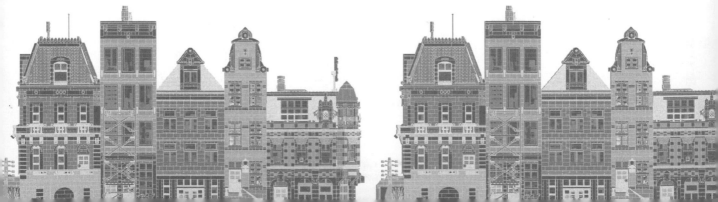